CLASSIC STYLE

HAND IT DOWN, DRESS IT UP, WEAR IT OUT

KATE SCHELTER

FOREWORD BY ANDY SPADE

GRAND CENTRAL
Life & Style
NEW YORK · BOSTON

Grand Central Life & Style
Hachette Book Group
1290 Avenue of the Americas, New York, NY 10104
grandcentrallifeandstyle.com
twitter.com/grandcentralpub

First Edition: May 2017

Grand Central Life & Style is an imprint of Grand Central Publishing.
The Grand Central Life & Style name and logo are trademarks of Hachette Book Group, Inc.

The publisher is not responsible for websites (or their content) that are not owned by the publisher.

The Hachette Speakers Bureau provides a wide range of authors for speaking events.
To find out more, go to www.hachettespeakersbureau.com or call (866) 376-6591.

Print book interior design by Sarah Gifford

Library of Congress Cataloging-in-Publication Data
Names: Schelter, Kate, interviewer.
Title: Classic style : hand it down, dress it up, wear it out / [interviews
 and text by] Kate Schelter ; foreword by Andy Spade.
Description: New York : Grand Central Life & Style, [2017] | Includes
 interviews with noted fashion designers.
Identifiers: LCCN 2016057329| ISBN 9781455540068 (hardcover) | ISBN
 9781455540075 (ebook)
Subjects: LCSH: Fashion designers--United States--Interviews. | Fashion
 designers--United States--Biography. | Fashion design--Anecdotes. |
 Schelter, Kate.
Classification: LCC TT505.A1 C53 2017 | DDC 746.9/2092273--dc23 LC record available at https://lccn.loc.gov/2016057329

ISBNs: 978-1-4555-4006-8 (hardcover), 978-1-4555-4007-5 (ebook)

Printed in the United States of America

Q-MA

10 9 8 7 6 5 4 3 2 1

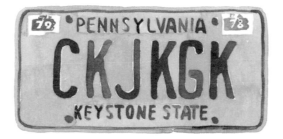

For Craig, Kitsie, Jennifer, Kristin, Graham,

Chris, & Charlotte

My Past, Present, & Future

CONTENTS

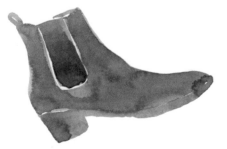

FOREWORD

I love this book.

I think it's because of how much I can personally relate to it. Like Kate, both my parents are creatives (both writers) who separated when I was eight years old. Like Kate, I discovered wonderful things like *The Concert for Bangladesh* album, movies like *The Rocky Horror Picture Show*, and Dumpster diving through my older brother. And finally, like Kate, I also found a strange, deeply personal meaning in my two-toned Vans sneakers and my hand-me-down Lacoste shirts. All these things helped shape my values and identity as a young teenager growing up in Arizona.

When I discovered Kate's watercolor illustration of Strunk and White's *The Elements of Style* in her first draft it all made sense. My mother had given me a copy of the book when I was twelve or thirteen. Poring over the pages of *Classic Style* I could see that Kate, too, has been heavily influenced by *Elements* and has unknowingly (or knowingly) applied its ideas to everything she does—from her personal rules for dressing to her design and art.

Edit out the useless and mundane. Make every word count. No unnecessary flourishes unless you really need them. Write about what you know.

Just look at the art: A pink bikini. A bottle of Mount Gay rum. Baby white Chuck Taylors. At first glance, these items don't seem to have much in common. But knowing Kate Schelter, they do.

Kate simply paints what she likes. From limes on an airmail envelope (one of my favorites) to an old Volvo station wagon, Kate carefully chooses her subjects based on their beauty and some personal meaning they have to her. There seem to be volumes of old photo albums inside of her head that she enjoys rummaging through from time to time. Then, when she finds something that she likes, she stops, and lets it out using her paintbrush and watercolor set.

At first, I saw them as portraits of places and things. But, the more I looked the more I saw portraits of the artist herself. Images that perfectly reflect the Kate Schelter I know. At the same time, they are proud badges we either wear or drive or stir a drink with. Simple items that define us, tell our stories, and communicate our values.

"But what do they mean?" a friend asked me. "Is she trying to say something about class? Society? America?"

"No," I responded. These are watercolors of the old school. No grand strokes, just small gestures.

I believe her process is purely intuitive. I believe she just has to feel it. And when she does—she feels it from the top of her straw hat to the bottom of her Stan Smith shoes.

—Andy Spade

P.S. Here are a few things I learned from the book:

> Observation is an art.
>
> God, Buddha, Zeus (and all the others) are in the details.
>
> Peter Pan collars > bustiers
>
> Thrift store shopping is a virtue.
>
> Preppy and classic are not the same.
>
> Authenticity is an aphrodisiac.
>
> E. B. White and Oscar Wilde are my superheroes.
>
> I miss my family's old Jeep Wagoneer.

These Are a Few of My Favorite Things

What does a classic black stiletto heel have to do with a Weber grill? On the surface, not much, except that they both bring me joy. But looking deeper, there is a lot of common ground. They're easily recognizable to all. Functional in their form. Deeply simple, yet also a combination of art, and maybe even a touch of perfection. They're classics.

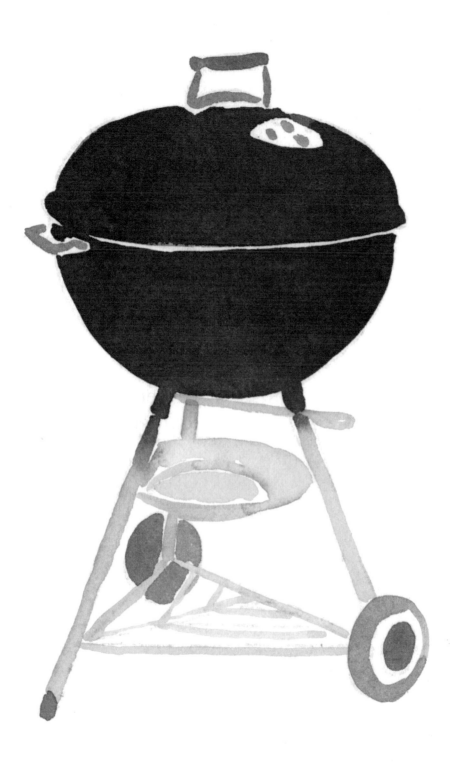

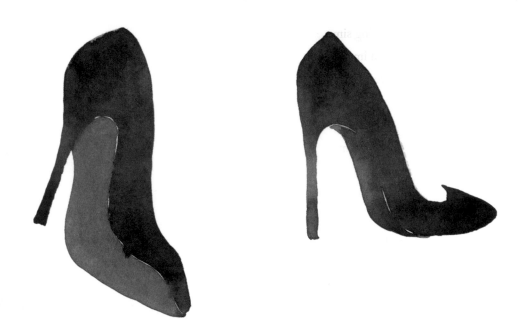

This is a book about classics of all shapes. As an artist, I draw inspiration from simplicity, timelessness, and good design—the deeply personal. I find it in the shoes and dresses I wear every day; in nature, travel, food, and the otherwise mundane objects I surround myself with. Classics are the cream that rises to the top of everyday life, the standbys, the worn-in, the dazzlingly simple. After years of editing, I've come to stand by my own personal classics, most of which you'll find here. At its core, this book is about my favorite things and why I'm interested in and devoted to them.

You could say a book like this is biased by design, because these are *my* favorite things, *my* pillars of survival, *my* greatest consumption habits, *my* needs, *my* wants (peppered with a few friends', too). That said, I hope they inspire you and help you begin to connect to your own collection of timeless essentials. Understanding my

own classic style—drawing simple pleasures from my belongings and surroundings—has been important to me throughout my life. I search for "the uncommon beauty in common objects" (Charles and Ray Eames)—the humble objects and useful toys. Studying the pieces I gravitate toward has helped me maintain an even keel and keep my integrity in the midst of an industry built on trends; it's brought depth to my career, my environment, my life, and the advice I can give to others.

I'm always asking, How does my _____ go with my _____? Is it a *moment* or a mistake, or is it *mine*? As a branding expert and stylist, I love watching people thrive when they begin to shape and understand their own styles and identities, embrace who they are and what they love, and express themselves to the fullest. Personal style can provide a unique transformation—when you display your personality outward with confidence, it creates an inward shift, too.

When it comes to style, I seek economy, efficiency, and ease—with a massive dose of personality and charm. I truly believe that doing more with your personal style starts with loving (and reinventing) what you already have and buying less. Classics, to me, are rooted in beauty, meaning, and usefulness. After many years spent in a fashion world that tries to reinvent itself each season, I've discovered that a much-loved cashmere sweater with patched elbows has a power in my closet equal to that of the most expensive runway piece out there. Classics are classic for a reason: Their material, construction, and time-tested trustworthiness are familiar.

Let this book serve as a starting place. I hope you'll see some of your own favorite pieces in my collection. Shop your own wardrobe (or your attic) and curate your own tastes through travel and discovery, and I promise you will uncover the timeless pieces that author your style. I hope your classics—like the people you surround yourself with—take you places, free you from constraint, and open up possibilities in your life.

Art to Fashion & Back Again

In tenth grade, I got my first taste of success in the arts—winning the Scholastic Art Award for a watercolor painting of an acorn squash. The piece was an abstract study of a squash from twelve different angles, using a palette of only three colors—an early lesson in doing a lot with a little. My teacher entered it without telling me, but I guess she liked it.

I followed my passion to the Rhode Island School of Design, majoring in graphic design and photography. I took off to Rome through their European Honors Program, where I sketched, painted, photographed, collaged like crazy, and studied the hand-etched typography of building addresses and the letterforms inscribed on the Pantheon's facade. We had no computers there. Everything was done by hand, including my résumé, which I drew with a technical pen in graphic colors cut with an X-Acto knife, color-copied, and sent around to places in Paris.

Word got out that an artist in residence at the American Academy called Ross Bleckner (whom I'd never heard of, but my fellow painting majors had) was calling for interns to prepare his exhibit. I clambered up the Gianicolo (Janiculum Hill) like an ant—I'll do it!—and spent a week sanding and painting walls for his exhibit because it *seemed like* the right thing to do. I tried to absorb everything I

could from my surroundings. I worked with what was in front of me. Art was my creative outlet, but as I took on internships at places like *W* in New York City and *Colors* in Paris, I ultimately felt the seductive pull of a world beyond my comfort zone—fashion.

But before I could get there, I had to do one tiny thing: quit my dream design job.

. . .

My first real job out of college was at a prestigious LA design firm, whose principals had both worked under Charles and Ray Eames. I was doing good work and was appreciated by the firm, but I was somehow bored and felt sleepy. I was told that I talked too loudly on the phone. I would finish my work and then not know how to fill the remaining time in the day. I felt caged, corporate—even in a creative environment. I spent all my lunch hours combing local thrift stores and Marshalls for vintage lingerie and designer shoes. Three months after I started, the *New York Times* invited our firm to participate in a logo design contest with other top design firms in the country. I quickly drew up my idea, signed my name, and added my entry to the pile my firm was submitting.

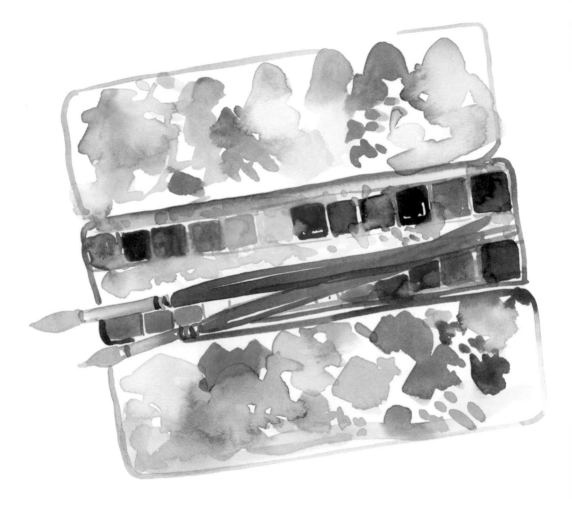

Just then, the phone rang and my friend Thomas Lauderdale from the band Pink Martini was on the line asking me to hop on a plane to Portland, Oregon, for a few days to art-direct the motion graphics in the group's first music video, featuring their song "Sympathique." I was beyond thrilled, but I already had a job. My heart was powerfully pounding to go to Portland. I summoned up enough courage to ask HR if I could take two days to tend to business I had. They agreed and off I went. I couldn't believe the band had asked *me*: my big break! I spent the next few days in the editing room with pure excitement driving me—my reality was aligning with my dream. I quickly realized I'd have to stay a full week to finish the project. Again, I held my breath and placed a call to the firm in LA and asked if I could have a few more days. I was really nervous when I dialed the phone. I felt guilty, ashamed to ask for more leave.

"Hi, it's Kate. How are you?"

"Kate, where are you; have you seen today's paper?"

"What? Um, I'm still out of town and I need until the rest of the week. Do you think that would be okay?"

"Kate, your logo design is on the cover of today's *New York Times* House & Home section!"

I was stunned. How was it possible to have two big breaks, pulling me in two separate directions, in the same week?

· · ·

A few months after Portland, I quit my job, went freelance, and never looked back. Over the course of fifteen years, with no particular plan, except, in hindsight, to follow what really excited me, scared me, thrilled me—and the people I admired deeply—I built a career in the fast-paced fashion world. To this day I have never been an employee of a company. I have been contracted for long periods of time,

but I have been on my own, moved to my own beat. Quitting was a wonderful, terrifying moment in my early career that taught me a lesson I've followed ever since: follow my dreams, my gut, and my mentors rather than a career that "looks good" to my parents or others in the outside world. I had to take the training wheels off in order to follow my heart.

One project at a time, I built my reputation as a "Creative Girl" for hire. I had business cards printed that said the same. I went toward people I was drawn to, looked up to, and admired, and from that came work. I challenged myself to approach mentors and heroes, cold-call firms whose work I respected (cold-faxing was my thing, too—I scrolled large Sharpie-written cover letters and sent them through the line). I'd meet with as many people as possible to clearly express interest in working together—no job too small. Some of the best jobs I've ever done were for free. I lived for the next big collaboration.

I began my freelancing career designing viral marketing campaigns directed at Gen Xers and Gen Yers for companies like MTV, Sony Pictures, Universal, and Jerry Bruckheimer. I was hired by trend maven DeeDee Gordon to do trend forecasting, a juicy profession that I had never heard of before, but for which, as it turned out, I had an intuitive knack. I lived and breathed fashion and design. I took pictures of every cool person I hung out with, stores I loved, places I traveled to, and things I made and found; and I wrote articles on the mood of cultures that were then sold to big corporations looking for content. I went everywhere with my camera, snapping away—street style, people, nightlife culture—whatever caught my eye.

CREATIVE GIRL

en voyage
KATE SCHELTER

I had these cards printed at Olivier de Sercey on Rue du Bac in Paris, right after graduating college. I had read *Breakfast at Tiffany's* and was inspired when Holiday Golightly wrote "traveling" next to her name on her mailbox. I thought it was cool so I wrote the same thing on my card in French because I didn't have a permanent address or telephone number yet. I thought I would just stamp it on, or write it in later by hand, when I did.

YASHICA
T4

Carl Zeiss T*

After four years of shooting pictures of people in amazing outfits, I moved to
New York armed with a huge portfolio and lingering fears that I had no idea what
I was doing and no one to teach me. Although I felt totally intimidated, I burst
forth onto the fashion scene as a *Vogue* photographer. I was lucky enough to find
photo editor Ivan Shaw, who graciously took me under his wing, believed in me,
took a chance on me, gave me real responsibility with real expectations, and told
me where to rent my camera and process my film. I went with it and I learned in
the process. At first, I was nervous—I hid in bed before my first fashion week
because my editor had not told me where to register for my All-Access Press photo
pass (duh, I just needed to ask). I was paralyzed by fear as there was no margin for
error at *Vogue*. "Don't fuck up" was the underlying message at every turn. The
job was extremely fast-paced, and I traveled all over the world, meeting a cast of
stars and fashion heroes I'd only dreamed about.

While photography was what had gotten me into the room, I found myself assisting stylists at *Vogue* and *Vanity Fair*, drawn to the fashion. My career was evolving, so I chose to focus exclusively on brand consulting and styling, giving up the photography side of things. I was really more interested in the clothes anyway: personal style and how people combined pieces to create a look.

For the next decade, I pounded the pavement in New York City; I worked all day styling, art directing, and consulting, and I went out every night. I traveled a lot for work and for fun, and I took my watercolors with me and painted.

In 2009, I met my husband, Chris, at a dinner party on a freezing January night—the kind of night you want to bail on your plans because you'd rather stay home, watch TV, and eat a burrito on the couch. But I braved the cold because I believe in showing up, and I needed some cheer during the winter gloom.

Romantically, at this point in my life, I wanted someone to *be* with, to start a family with; someone who mattered to me more than my career had mattered. I was tired of seeking and of dating—I really missed the deep relationships and closeness of my own family. On our first date, Chris asked me to go see the New York Philharmonic, but then he changed his mind and took me to a live comedy show where we had soggy nachos and watered-down drinks. We laughed too loud the entire time and stayed up all night. The stand-up comedian called us out in the back row, shining a spotlight from the stage on us: "Hey, are you guys on your first date? You two are getting married." The date was a welcome change, if not a far cry, from the glamorous fashion affairs I was used to. We've been together ever since.

We were married in 2011 in a small family wedding, in an olive grove on a hilltop in Italy, where you could hear birds chirping, the trees rustling, and a rooster roosting in the valley. We wrote our own vows, were married by my best spiritual friend, Eddie Marashian, and had a Quaker period of silence, during which nearly every guest stood up and spoke. Finding my partner marked a turning point in my life, and as it seems now, in my career.

PISA

FLORENCE

SIENA

MONTALCINO

CASTELLO DI VICARELLO

CASTIGLIONE
DELLA PESCAIA

PARCO
DELL'UCCELLINA

TALAMONE

PORTO
ERCOLE
Hotel Il Pellicane

T U S C A N Y

ROME

FIUMICINO
AIRPORT

N

ITALY

KATE & CHRIS
23 JUNE 2011

SCHUMACHER

Back in New York, the watercolor paintings I'd done while traveling caught the eye of my friend Julia Chaplin, who asked me to illustrate her book *Gypset Travel*. I began painting more and more to complete the book assignment. During this time, I became pregnant with our first child, Charlotte, and Julia Restoin Roitfeld asked me to create illustrations exclusively for the brand she was starting. I painted every day at our kitchen table, Instagramming as I went along. I went from being a fashion stylist and luxury brand consultant who painted rarely on holiday, to being a watercolorist who painted every day for luxury fashion brands. John Derian started selling my original paintings at his store. Suddenly I was taking private commissions. I had my first solo gallery exhibit in 2014, and my second in 2015. And, here we are…back to where I started this adventure, painting—a dream launched by an acorn squash watercolor.

The Schelters

When you fly out of the womb last, with three older siblings, suddenly, you have a lot of catching up to do. I began my life running. I was the caboose, pulling up the rear at lightning speed, trying to catch my sisters' and brother's shadows, nipping their coattails. I wanted to be just like them, followed their every prompt, and heeded their every nugget of advice and experience. My whole life has been about reaching out of my comfort zone to catch up. Reaching for a career, reaching for my dreams, reaching to get my first period (I was the last of my friends) and a bra (I had no boobs), reaching to secure internships and land jobs, reaching to get in. I've been determined to catch up, make myself heard, and prove myself at every turn.

I was born and raised in a beautiful bucolic pocket of Philadelphia called Chestnut Hill—my parents walked three blocks to the local hospital when my mom went into labor with me. Behind Jennifer, Kristin, and Graham, I was the baby—a real, live toy!—born five years after my brother and bathed in love and attention. From birth I've been armed with a certain kind of protection that only siblings can provide—a Schelter sheltering from the world that comes in the form of *we've done this before*; *we've broken in our parents for you*; *we've paved the way*; *our experience is your confidence*. There was a natural order and security to following my leaders: Whatever they did I

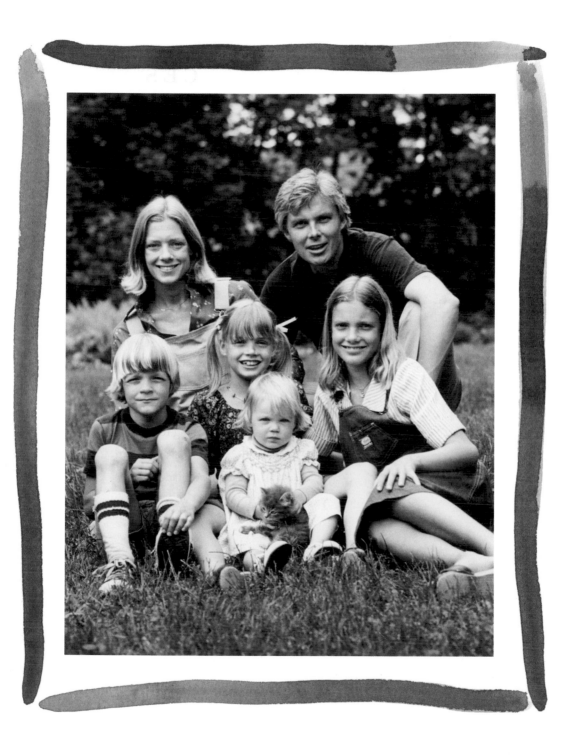

copied, whatever they had I wanted, whatever they said I took as fact, wherever they went I stood. They defined my life by what they exposed me to: lingering bottles of shampoo in the shower, sneakers they wore to school, magazines they read, movies, music, *SNL* sketches, Eddie Murphy records, *Caddy Shack* quotes, sunscreen they slathered on their skin, inside jokes and slang they used casually among friends.

We were a litter of love, the four Schelter kids. I was eight when Jennifer went off to college, and eleven when Kristin did; when Graham left I was an eighth grader and suddenly all alone, and my parents separated—the family shattered into six shards. I had a pair of parents, but my satellite siblings were my true touchstones of security and reassurance. They protected me from the pain of my parents' separation—reachable by phone, letters, and school breaks when they'd return home and I refused to leave their sides. I felt like an only child in high school, with no blueprint to follow. I was suddenly left to my own devices to make stuff up, play by myself, and devise my own entertainment: creating, drawing, collaging, and dressing up.

Alone, I needed to assert my own personality, a strange feeling after being one of four, a pack where the family unit came before the individual person. It was a turning point that was painfully solitary for me and scary at times. Assertiveness became my survival mechanism. When I turned fourteen my mom let me decorate my own room: together we sponge-painted the walls and dormered ceilings, carpeted the floors, Pierre Deuxed the bed with matching lampshades—my first grown-up bedroom from concept to completion. Then I went into my closet and painted a mural of a daffodil with my watercolor paints and graffitied it with a Sharpie and crayons. I made it my own. I asked my friends to sign my closet wall when they came over. It was a personal space where I was allowed to experiment. I papered my walls with magazine ads—BMW's "Ultimate Driving Machine,"

Mercedes, Guess's Claudia Schiffer, Clinique's 3-Step Skin Care. I didn't own these things, but I admired them, the shapes, the fantasy, and the clarity of these images. I could dream about them instead of listen to my parents fight. They reached into my heart and yanked on the strings. I was drawn to these visuals before I even understood the massive engine propelling advertising. In addition to the ads, I made collages—I'd isolate single words from a headline and juxtapose them with other words. I'd staple fabric, Ben & Jerry's ice cream pints (empty), fabric, tea leaves, the back pocket of my jeans, paint, marker, Scotch tape—anything I could find—and hang the finished product on my wall or give it to my closest friends. This was my art. My world.

I have always loved what I love. It's deep inside my DNA, a visceral, confident feeling that separates what I like from what I don't. Many people have said that I am the combination of the best of both my parents: the fanciful/artistic flourish and romance of my mom, with the practicality and focus of my father. This simplification is accurate: the no-frills, sturdy "form follows function" objects that my dad has inspired (Braun alarm clock, sharp chef's knives), with the decorative details (Quimper faience, Scalamandre wallpaper) that come from my mom's love of art and history. My own take combines their mix and takes it a few steps further.

My parents were all–Ivy League: a sort of *Love Story/Sound of Music/*Von Trapp hybrid. My mom, Kitsie (Katherine), is a passionate, prolific, creative force. In addition to making our (matching) clothes by hand, running a leading interior design business, traveling the world, and assembling Christmas gingerbread villages from scratch (tree ornaments, too), she made a career out of instilling art and culture into her four

Our station wagon
staple: carpool snack.

children's lives. She rejects the term "preppy" (even though she is) and embraces the term "classic." My dad, Craig, likes simplicity in good design—life's little pleasures. An architect by trade and a city planner by profession, he has a head for business— dependable, reliable, does things on time. Their tastes and values overlapped, complementing their differences.

My family provided me with a fertile foundation and all the material I needed as a jumping-off point into my own independence. They gave me tools to create my own blueprint, they taught me right and wrong, and they left it to me to decide which rules to honor and which rules to break. There were many years when deep pain and loneliness lurked in the background of my adolescence. My parents were pulling me, unintentionally, in both directions, while at the same time I wanted to be with all three siblings simultaneously. It left me bare, naked, raw: Craving unity. Craving protection. Craving direction. I was forced to lead myself, to choose confidence, to pull up the rear, and to pull myself up, to march to my own drumbeat and those of my closest friends.

MY FUTURE

The Lighthouse Effect

I have had an almost overexposure to *things* during my many years in the fashion industry. As a photographer, art director, editor, and stylist, I was exposed to luxurious trips and travels, hotels, clothes loaned from designers, and food on the finest china. I enjoyed the ride tremendously (and rode the wave all the way). But the buzz started to wear off: The silver began to tarnish. I was having the time of my life and living the best version of my dreams, but noise and clutter filled my tiny studio apartment and started to drown out my own voice.

Burned out on "luxury" and the constant trend race, I reverted to my original way of dressing—a lifestyle of irreverent, DIY freewheeling ease. I started to gravitate toward things that not only made me look good but also made me feel good (even though I do believe these are inclusive). In the mirror I saw *myself*—stripped of all the pretense.

I haven't looked back. A mother and wife, I stand by my philosophies and style staples—and with a child who needs all my attention, I heavily rely on them when I have no extra time. Today, real luxury, to me, is ease, discipline, and personality: surrounding yourself with the people and the things you love, in the place you want to be, and nothing more. Luxury is what comes naturally but needs working at through practice, determination, and fine-tuning. Luxury is feeling that you don't need

anything else to feel whole. Remember, you choose your space, your clothes, and you choose what you want to surround yourself with. You are in charge.

Style trickles into everything you do, who you are, and who and what you attract in life. Whittle down your style to what matters and project what's meaningful to the world: Be the lighthouse. Be honest. Be real.

The "lighthouse effect" is a metaphor that my sister Jennifer introduced me to: Be the light that you wish to attract, be yourself, listen to your inner voice, practice, edit—BE what you love, and you will attract the same faculties, people, principles, and things right back to you. The key is to have vision. The key is to be specific about whom and what you love, and virtuous in keeping with your vision to avoid a collage of compromises. Anything is possible when you can envision it and work hard. The goal is not objects themselves, but—*to be you.*

Tap into your passions, your motivations, and your biggest fears. The jitters are love in disguise, reminding you that you're getting closer to what you want. Face it. Go toward it. Do it. Dive into your most meaningful experiences and relationships—the ones that make you feel like you're alive. Don't worry if you can't access what you want just yet. It will come. For now, what do you surround yourself with? Are you putting yourself out there? Are you knocking on doors? I hope you can see that the things you might take for granted—your toothbrush, your wristwatch, your grandmother's needlepoint pillow, your socks, your shoelaces, the dish at your favorite restaurant— are defining your style and who you are and the message you're sending to the world. You are your style.

"Less is more"

PART ONE
Define

What is a classic? A classic is timeless and it resonates emotionally. Classics define their category, like the trench coat, the little black dress, a fisherman sweater—they garner universal appeal because they have been useful throughout time. They are immune to trends and have no expiration date in sight. In other words: your favorite things. Think: the unique, idiosyncratic mix of stuff you never tire of, the objects that you rely on, the stuff that makes you happy, the indispensable tools that are useful, the people who deeply inspire, reinforce, and define who you are, and what makes you tick. Something designed and edited, yet warm and easy. Something useful and beautiful. Something soulful.

Classics are the stuff of love: A complimentary black comb with *Somerset Club* printed in white text that I took from the powder room when my grandfather used to take my family to dinner there. The Beverly Hills Hotel pink-and-green sugar packet that hangs on my wall, just because I like it. Certain objects are deeply meaningful to me. Others I don't care about that much. With classics, you have to trust your instincts. I love deeply the objects that bring me joy, even if no one else notices their importance. My world is *my world*, and I've chosen every object in it carefully, whether iconic, luxurious, or banal. My classics broadcast my interests— my mixture of personal preferences. They help me through my day, they project my personality, my sense of humor, my core, and they speak my heart.

Surround yourself with the things you love, regardless of provenance. What do you reach for? What's nostalgic, ergonomic, comfortable, effortless, or requires work, but is totally worth it? That's a classic.

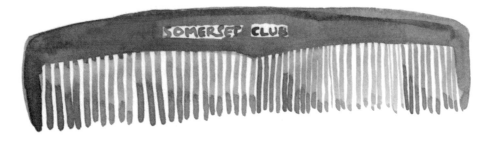

My Classics

My classics go beyond my closet and my jewelry box and extend to the far reaches of my entire life: our house, my medicine cabinet, my preferred mode of transport, my favorite restaurants, and where I choose to travel. Any object that I use on a daily basis or come back to again and again is a classic. My classics are a distinctly personal matter. They are not defined by tradition, price, or trend.

Classics don't have to be a prim and proper string of pearls. My mom is proof that classic doesn't always mean preppy. My mom might wear pearls with a dress she handmade, and I'd take the same pearls and rock them with a cut-off jean skirt and flip-flops. The dark indigo Levi's that belonged to my father in college— I made them into a cut-off miniskirt by opening and rejoining the inseam, and I wore it until it turned pale blue. I still wear the skirt. Your classics should be worth every penny, well-made, old and new, unlimited, free, breathing. They should be worn and used and loved.

I carry a Coach men's wallet with buttoning change purse that I got for Christmas in ninth grade from my dad. I've carried it in the back pocket of my jeans (high school trend) and continue to use it every day. I never traded up. It is threadbare, smooth as water, and holds my change, my money, and my cards. People ask me about it. It looks like *Mad Max*. If fashion is what everyone's doing, classic style is what I'm doing—it's how I live when I'm really being myself. Anything else feels false.

Classics aren't always inherited. I sometimes invest in them and spend hard-earned money. But I do so with great care. And discipline. I dare say my classics align me with my true self. They just feel right. You'll know yours. Classics don't interrupt or get in the way; they don't keep me from doing what I want to do. My classics lift my sprits and support my goals. Life is about living: doing and being!

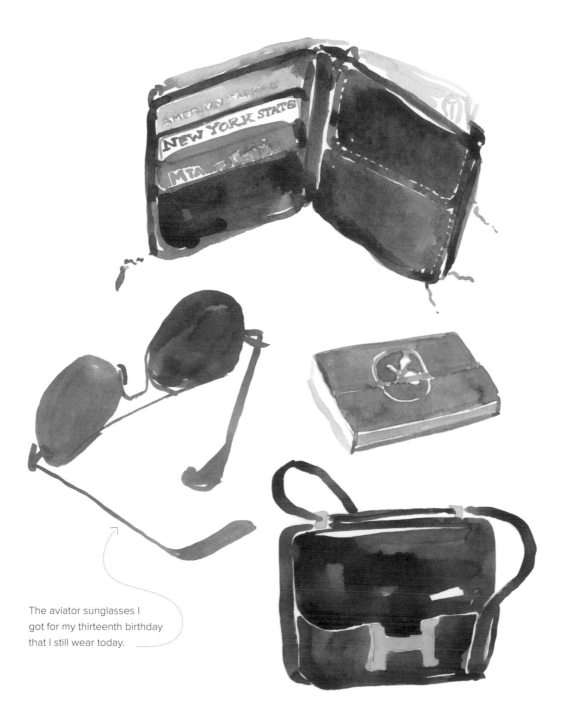

The aviator sunglasses I got for my thirteenth birthday that I still wear today.

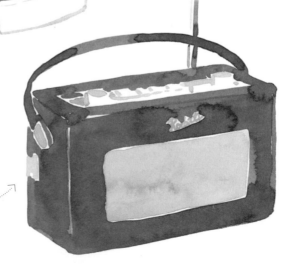

Roberts Radio dial permanently tuned to *NPR'S FRESH AIR WITH TERRY GROSS.*

The dark indigo Levi's that
belonged to my father in college—
I made them into a
cut-off miniskirt
by opening and
rejoining the
inseam, and I
wore it until
it turned
pale blue.

Have a Point of View

My godmother (of sorts), Mary Bradley, is an exuberant native of St. Louis, a Missourian of the self-proclaimed "Mink & Manure" set, with a laugh that you can hear three blocks away. She's over the top, a phone that's ringing off the hook with bravura and personality. She lives in Connecticut and watches the Cardinals on TV, she plays bridge weekly, she wears gold jewelry that belonged to her mother, she's carried the same Mason Pearson hairbrush in her handbag for decades. She does not mince words and loves to impart advice: "Nothing good happens after midnight." Or "When you ask for money, ask politely and then wait in silence." She doesn't say the safe thing; she is honest.

She's clear and consistent about her tastes and doesn't apologize for them, yet she is tolerant of others' views, amused by them, and respectful and willing to laugh off differences. She's old-school. She loves to say things such as, "Isn't it *très charmant?*" "Little Kate, isn't this tablecloth from Paris *divine?*" "Isn't this scarf *très charmant?*" "Isn't this hot dog *the best?*" "We went to such and such restaurant and it *is to die for!*" Rarely, things can be "*the pits. Help me, Rhonda.*" She's a glass-half-full, silver-lining optimist. She says things her own way, with conviction. By naming it "*très charmant,*" she makes it so. It's a form of appreciation for the simple details in her belongings—expensive and cheap, new and old—and the pleasures in her friends and environment. She's happy because she's grateful, and her opinion acknowledges her preferences. You know exactly where she stands.

When I make our bed, I use a granny chintzy
boudoir pillow because it livens up the
room. Skip the layers of unnecessary euro
shams, or rows of pillows that you'll throw
on the floor, and splurge on the boudoir
pillow. It's bed jewelry that you can hug—the
charming pop, the *TRÈS CHARMANT* moment.

Protect, practice, and preserve everything that you believe in, everything that you value, and everything that you love. Make up your mind, have an opinion, and go with it. Initiate, don't imitate! When you imitate you aren't yourself. Don't stay in the middle. Take a stance! Decide, commit, and do.

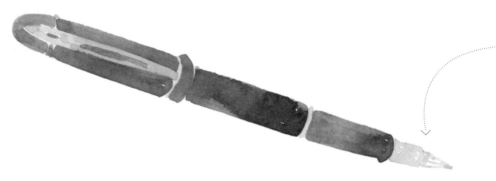

Signatures

What does it mean to be authentic? It's when you think: *I wish I had thought of that!* Someone who has authentic character is someone whose manner you can't copy, because it is so *Charlotte* that only Charlotte can do it. It comes naturally, with some thought behind it, and it's not too obvious. The way you wear a hat, your favorite ChapStick, or the way you let your hair grow in natural tousles. Your favorite pen. Authentic style is a combination of elements whose sum is greater than each element on its own. Something simple, pure, and true that you can spot and recognize instantly—you can feel it—like a signature, a swoop of the wrist.

Furthermore, it's an equation of subtraction: When elements are removed, the details and idiosyncrasies that remain read 100 percent as the person herself. "My mom always said, 'Don't be a show-off,'" says Andy Spade. "'You don't have to put anything on that's superfluous.'"

The Waterman fountain pen I bought in Paris in 1997 for one hundred francs—a splurge that has lasted me twenty years. I've written a million words with it, hundreds of notes and letters. I like my handwriting the best when I write with this pen. The nib is just right.

SOMETHING OLD NEW BORROWED CHARMING

DAVID NETTO

Interior designer and writer

LOS ANGELES

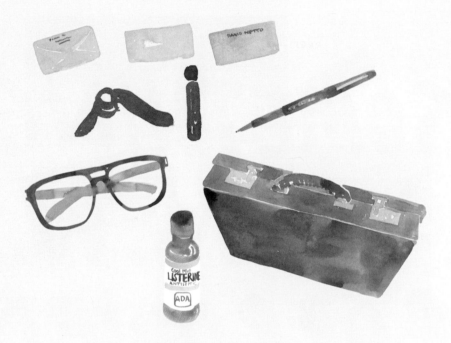

CONTENTS OF YOUR BAG
Swaine Adeney attaché case, Celine glasses, Listerine, knit tie (navy or black),
Dempsey & Carroll stationery, Paper Mate Flair felt-tip pen.

ALWAYS IN YOUR FRIDGE Branston Pickle.

QUICK DESCRIPTION OF YOUR OVERALL LOOK Messy.

YOUR DAILY ROUTINE Thinking up dreams for other people.

FAVORITE CANDY Gummy fried eggs.

SKILL YOU DREAM OF MASTERING Speaking Italian.

DISHES Royal Copenhagen.

FAVORITE ART IN YOUR HOUSE My children's drawings.

MOST WORN-OUT SHOES My Danner boots, the older the better.

PRODUCT YOU'VE USED SINCE HIGH SCHOOL Frizz Ease.

FAVORITE SONG SINCE HIGH SCHOOL
"The Girl with the Curious Hand" by Digney Fignus.

BOOK YOU KEEP CLOSE AND REFER TO OFTEN
Confessions of Felix Krull by Thomas Mann;
The Confidence-Man by Herman Melville.

MAKES YOU FEEL COZY Being on a train.

PREFERRED METHOD OF CORRESPONDENCE Love letters.

FAVORITE VIBE TO CHANNEL Gene Wilder.

COMFORTS YOU LONG FOR
One more dinner with my mother.

FAVORITE PLACE IN THE WORLD
Wherever my children are.

FAVORITE MEAL TO COOK Spaghetti for my girls.

SPORT
Waterskiing.

SUNGLASSES
Sol Moscot.

NECESSARY EXTRAVAGANCE
Owning Bentleys on each coast.

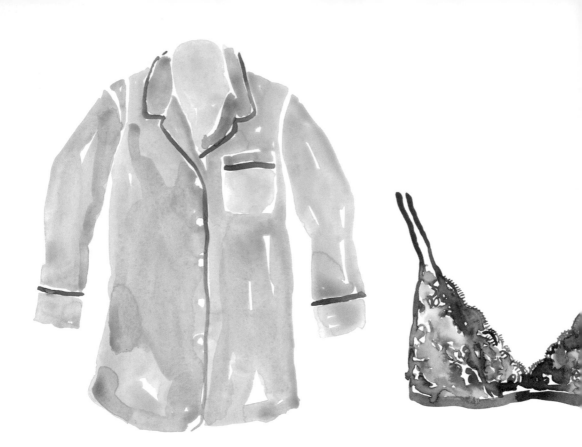

Your Style Is Your Pajamas

Your style is what you are unaware of; it's what you do naturally, your outward DNA. It's your pajamas as much as it's your wedding gown. Your style is your character.

Your natural style that's all your own can be loaded with references to people and places you love, as well as surprising ways of doing things. You are much better off trying to be yourself, following your natural tendencies and interests, than trying to create "a look." When it comes to taste, start simple. Ignore your insecurities and feeling that a look isn't doing enough or that you should be wearing such and such designer. Remind yourself, *Am I being myself? Do I feel like me?*

Picasso painted most of his masterpieces wearing little more than a robe, and writer George Plimpton was known to roam the *Paris Review* offices in his boxers.

—CHAD BURI, CO-FOUNDER OF SLEEPY JONES

Doug Scott

My favorite typography teacher in college, Doug Scott, was in the military early in his career, before he became a graphic designer and started teaching. He said it instilled in him the values of being efficient, clear, direct, and deliberate in everything he did. In class, he stressed being concise in every way possible. He asked for pithy writing, because he could read something faster than listening to you explain it. He is a great person, passionate, and he teaches this philosophy in the form of graphic design.

Good layout design, according to Scott, is something you can easily describe to someone over the phone. If it is too complicated, it doesn't work. Good typography is simple, clear, impactful—details are carefully considered. Life is naturally filled with ambivalence and emotions and excess: Make a statement clearly and concisely. It may be stylish by default, not by intention. Style is the gravy that's left when you reduce the juice.

Bodoni
Univers
Baskerville

Trade Gothic

Gil Sans

Goudy Old Style

Helvetica

Centaur

DIDOT

Bembo

Futura

What Can You Describe to Your Grandmother Over the Phone?

My favorite things are classic because they define their specific category. Classics are recognizable by their distinct shapes. Their iconic form is unmistakable as anything else. Visualize a Saab 900 sedan or a VW Bug, a simple teakettle, a rotary dial telephone.

They are ergonomic, comfortable in your hands, and feel good to use. They ooze charm and warmth. You want to touch them, pick them up, put them on, drive them, wear them. You relate to them; you are attracted to them; you love them. They create an experience for you. There's an ease when you use them, a trust in them—a loyalty—and you return to them over and over again because they bring you joy. They are *so you*, you wouldn't do it any other way.

Classics that your grandmother would recognize:

→ A Pendleton blanket is fleece white with primary-colored stripes.

→ Coppertone sunblock is brown, rectangular, with an orange cap and sunset.

→ A Weber grill is a red dome with tripod legs and an airhole.

→ Stan Smith sneakers are white leather and laces with a green tongue and heel tab.

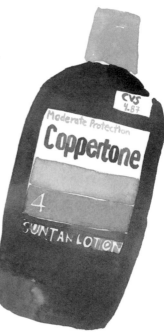

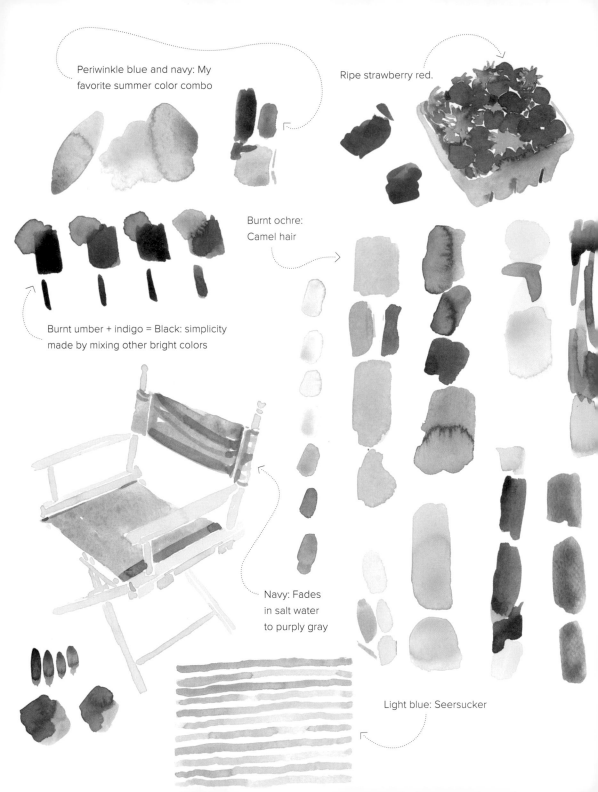

Periwinkle blue and navy: My favorite summer color combo

Ripe strawberry red.

Burnt ochre: Camel hair

Burnt umber + indigo = Black: simplicity made by mixing other bright colors

Navy: Fades in salt water to purply gray

Light blue: Seersucker

"Tennis ball" yellow

Cadmium yellow:
Rain slickers and
foul weather gear

Cadmium red:
After years of sun
bleaching, turns into
a coraly pink, aka
Nantucket Red

Grass court
green; "new
growth" spring
trees/shrubs green

Limited Palettes: Using an Edited Selection to Produce a Clear Message

The great art masters (Bonnard, Rothko, Monet) have known for centuries that painting with a limited color palette will achieve color harmony, depth, and unity within a composition. A beautiful painting is created with color limitations rather than every crayon in the box. The limitations that you can mix are what makes the mix significant.

It's fun to see what people can do with limitations—if they lead to writer's block or spark infinite creativity. The initial reaction toward less, many times, is a feeling of fear, of less is less. But once you get over the hump, you can see that an edited selection can produce a clearer message.

I think you can be more creative with less, but you have to have the right tools and mind-set to know which "less" you want to use. The creativity, the mixture, the juxtaposition is what I cherish, especially when it's unexpected and singular to someone's point of view, unique. The mix—the style smoothie—maketh the man.

Little Sister

In my eyes, no one had cooler style than my siblings. I worshipped their wardrobes. My sisters, Jennifer and Kristin, were my ultimate bragging right—my messiahs of blond ponytails, lacrosse sticks, Juicy Fruit chewing gum, frosted pink lipstick, and Maybelline Great Lash mascara. I snuggled at the foot of their beds like a cat, listening, asking questions, refusing to leave their rooms. My brother, Graham, whose room sat across the hall from mine—separated by a bathroom with a claw-foot tub and a touch-tone telephone with a forty-foot cord—had an epic collection of T-shirts from colleges and boarding schools (and their sports teams). I would steal them for tennis and lacrosse practice. He was

preppier than I was, and he wore Stan Smiths, khakis, Oxford shirts, a J.Crew barn jacket, and an L.L.Bean fisherman sweater. He was a sailor who taught kids on the coast of Maine in the summertime. He'd keep me up at night playing REM, the Smiths, and Run-DMC records on his Denon turntable. His epic mixtapes were the sound track to our morning car pool (white two-door VW Rabbit, standard, diesel, bought used).

One by one, as my siblings left for college, I invaded their closets full of Fair Isle sweaters, abandoned prom dresses with matching dyeable shoes, plaid shirts, and perfectly ripped jeans. I begged to borrow coveted coats, tops, and dresses when they'd return home on break.

Nostalgia can play a part in creating classics—a smell, a feel, a memory. We let things back into our lives because we are deeply comfortable with them, their function and usefulness. Our personal histories, our childhoods, offer imagery as aesthetic prompts, and then something "sticks" when certain items become useful to us again as an adult. We go with what we know. We start with the familiar, then experiment and branch off from that foundation.

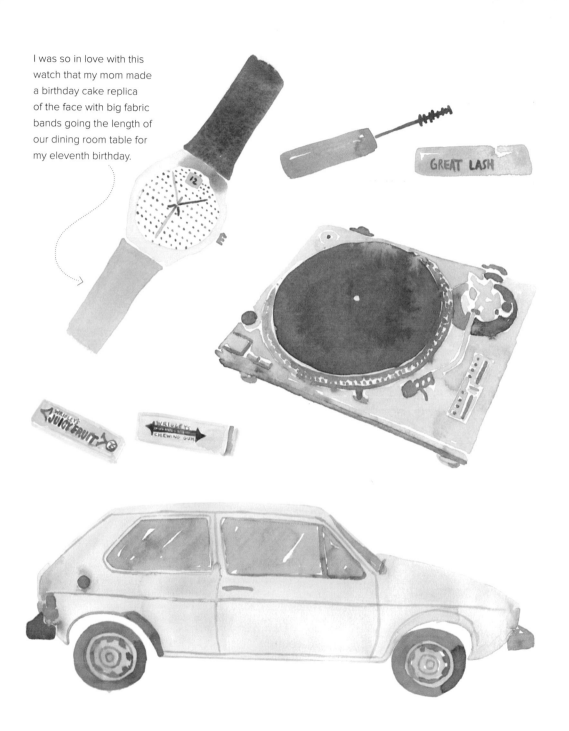

I was so in love with this watch that my mom made a birthday cake replica of the face with big fabric bands going the length of our dining room table for my eleventh birthday.

What Makes an Outfit Stylish?

A worn-in pair of shoes with a lumpy fisherman sweater; a beat up T-shirt and jeans with your mom's signet ring and your grandmother's gold bangle; your new patent leather pumps, a cocktail dress, and messy day-old hair; estate jewelry with a gown; faded shorts you've worn since college with a straw bag and tan leather sandals that you don't remember where you got; a messy pony(tail) with a black grosgrain ribbon tied in a bow; a cashmere cable-knit sweater with bikini bottoms, barefoot; a strand of pearls with a T-shirt; a brimmed hat when it rains in lieu of an umbrella (it will keep you drier); leopard on leopard, denim on denim, white on white, black on black, color on color; flats with a gown; sneakers with a suit; bathrobe with piping and slippers; colorful lace bra peeking through a sheer blouse; overalls for housework; jumpsuits; jewelry you never take off; walking the dog in a baseball hat and your mom's fur coat; a bandanna worn as a kerchief in the hair; a panama hat that has unraveled to bits of straw after humidity and long wear; navy stripes; espadrilles worn with the heels stepped on; black glasses; a weathered (gold Rolex) wristwatch that was made the year you were born; your worn-out Converse sneakers; a certain messiness; a certain polish.

RITA KONIG

Interior designer and writer

LONDON, ENGLAND

PREFERRED MODE OF TRANSPORT Vintage Fiat 500.

ALWAYS IN YOUR FRIDGE Mustard chutney.

QUICK DESCRIPTION OF YOUR OVERALL LOOK
Expensive and shambolic.

GO-TO DRINK Gin and tonic.

SKILL YOU DREAM OF MASTERING Cooking.

BREAKFAST In bed.

**PIECE OF FURNITURE YOU REALLY
LOVE AND USE EVERY DAY**
My open-armed armchair. It was my great-
grandmother's and I always sit in it.

PRODUCT YOU'VE USED SINCE HIGH SCHOOL
Vichy deodorant—imported from Paris. A bit mad!

NAIL POLISH COLOR Bordeaux.

FAVORITE FONT Gill Sans.

DISHES Marie Daâge.

MOST WORN-OUT SHOES Chanel ballerinas.

**WHAT YOU BRING HOME IN YOUR SUITCASE
WHEN TRAVELING ABROAD**
Something local for my drinks tray.

INSIDE YOUR HANDBAG A pacifier, hand cream, and a lip gloss.

COMFORTS YOU LONG FOR
Financial security, a full-time cook, and a driver.

MAKES YOU FEEL COZY Clean sheets and a storm outside.

Proportion and Scale: The Golden Section

Scale is a poetic art form. The right sense of scale is a complicated business; it requires the pursuit of plainness, simplicity, and restraint to achieve balance. Scale is particularly hard to get right. You know it when you see it. You feel it when it works. Scale is a quality that is peaceful when it's successful and deafening when it's wrong. Consider a ceiling that's too low for the room and feels constricting and stressful, in contrast to a small room with intimate proportions that feels cozy and inviting. A hem that is just right for your leg length or a favorite pen that holds your hand.

The golden section, also known as the divine proportion, is the perfect—golden—ratio of the longer side of a rectangle to its shorter side and is generally agreed to be aesthetically pleasing. The golden section appears in some patterns in nature, including the spiral arrangement of leaves and shells, and is universally accepted as *the* equation for all things perfectly proportioned in the design and architecture world because it is based on the scale of life and the human body. It begins and ends with your body's proportions: your height; your level of eyesight; the size of your arms, legs, and hands.

Identify your classics! What is the perfect shoe, the perfect chair, the perfect kettle, the perfect shade of blue? You just know it when you see it. It feels right. It feels better than the rest. You want to wear it out of the store. Your good instincts and experience will guide you with a great sense of discovery and excitement—the cream rises to the top.

Scale is what makes a classic.

Classic, Not Preppy

My mom, Kitsie, helped define the term "classic" for me. She has a distinctly American style through and through, but she borrows heavily from Europe. Her motto: "I like simple and underwhelming!" She loves tradition but draws the line at preppy. Preppy is canned. She rejects preppy and embraces traditional, which is enduring and simplified—understated elegance—based on a way of life, not trend. Gorgeous is a dash of DIY, durability, and simplicity.

She grew up on a farm in Bucks County, Pennsylvania. She talks about how she felt like an outsider when she moved a few miles west to the Main Line, a suburb of Philadelphia, to attend the Shipley School, even though she looked the part terrifically, and her family was listed in the *Social Register*. She didn't like the formality, the cliquey all-girls school. She hated the proper and wanted nature, simplicity, farm life. This is her voice-over, on repeat, my entire life.

My mother is dashingly beautiful—the real *Philadelphia Story* Grace Kelly—with movie star features: long legs, tiny waist, convex clavicle bones that you can hang from, blond hair parted in the middle. She wears her hair chin-length, occasionally pulling it into a ponytail with a ribbon bow or tucking it under a white tennis visor. She's Mom, wearing the same clothes her entire life. Her wardrobe doesn't go out of style. She doesn't wear T-shirts; she wears Breton stripes. Dr. Scholl's clogs (navy or red) are her flip-flops; Tretorns are her tennis shoes. Espadrilles in the summer and furry Norwegian felt boots with red laces in the winter. She wore a black cape with

knee-high flat boots and a black hat, splurges from little Parisian boutiques—I remember the distinct feeling of "cool" the first time I watched Mom shop and spend more than fifty dollars on something. There was a red Michael Kors jacket (that she later gave to me), a khaki Banana Republic safari jumper with a camo ammunition belt that she wore with clients and to pick up car pool—purchased from the original safari-themed jeep and giraffe decorated Banana Republic. Her Coach "pocketbooks" were never called "bags" or "purses," and she wore scarves in every different way, color, and style.

She didn't get pierced ears until she was fifty-six, and then she decided to let them close up and go back to wearing clip-ons. She laughs in the face of aging and she's fit: We taught her to do a flip off the diving board when she was seventy-two.

Mom's matchy-matchy symmetrical style means everything is tidy, beds are tucked in, the whole scene is neat and polished—a storybook. She likes hints of modern flourish like Marimekko wallpaper

sheets amongst wicker furniture; white ironstone china that is practically generic-looking in its plainness. She wore denim overalls with a flower tucked behind one ear and seldom wore a watch. She bought tablecloths and scarves in Provence that she had her seamstress make into a sundress and shawl. Her favorite patterns are (Breton) stripes, stars, hearts, Indian block prints, and anything that is handmade with a touch of folk artistry: Mexican embroidery and pottery, French faience, wooden Russian spoons, patterns from Pays Basque. Duralex tumblers were our everyday glasses. My mother breathes classic but never has to name it. Nothing is ever called chic. It just is.

Buy the Best, Buy Less, Leave the Rest

My dad, Craig, is a creature of habit with extremely loyal purchasing habits. With a German-American heritage, he has an innate instinct for things that work and are dependable, reliable, and punctual. His style is unwavering. It's clear, not outspoken but always stylish, always Dad. You can rely on what he's going to wear: He doesn't surprise you, and he looks like himself. He's thoughtful and deliberate about what he saves, spends, and very occasionally—when he can—splurges on. He's in a crisp clean shirt and double-breasted suit in the city, and fraying Patagonia "Baggies" shorts and T-shirt on the weekend when he's cutting the lawn. He wears many articles of clothing from his college years: Danner boots, Woolrich lumber jacket, a black sweater from Williams with purple number "1964." A twenty-six-year-old Hawaiian shirt hangs among Brooks Brothers shirts (when the shirt wore through at the neck, he'd have a seamstress turn the collar—that's why men historically wore shirts with detachable collars); a made-to-measure blazer from the Andover Shop; an Italian cashmere jacket he bought himself on sale at Barneys (with my counsel); crusty DockSiders; Church's shoes (resoled numerous times; look brand-new); a few rep, woven, bow, and Hermès ties; a colorful pocket square on occasion; three pairs of cuff links (when he feels like it); a thirty-three-year-old leather

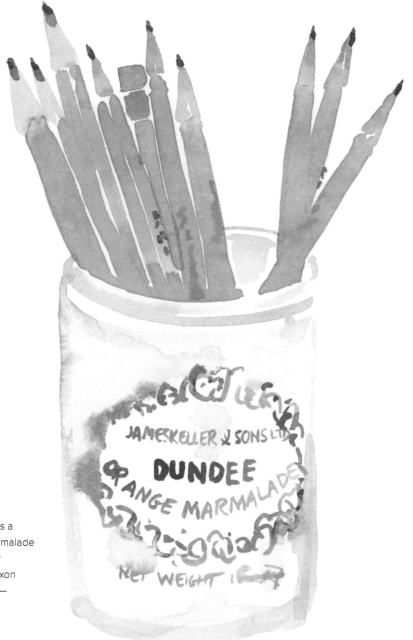

On my dad's desk sits a ceramic Dundee marmalade jar filled with a pointy bouquet of yellow Dixon Ticonderoga pencils—sharpened tips up.

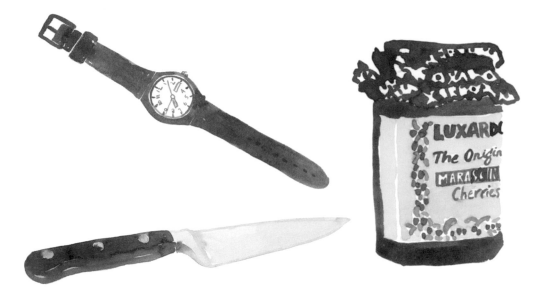

Schlesinger briefcase; and "my gray bag," his signature little Lands' End nylon duffel with black piping and black initials, which he takes everywhere with him (contents: address book, written carefully in architect lettering since 1985, checkbook, sharpened pencil, calculator, Lamy fountain pen, comb, toothbrush, and paste). "Where's my gray bag?" is the first thing you hear him say when he's trying to locate his life in a bag.

He is measured, but he is also warm and loves to laugh. He likes simplicity in good design—life's little pleasures—what he calls "the best." The best watch (colorful Swatch; he has a nicer gold one with an alligator band that he complains gives him a rash); the best jeans (Levi's 501 button fly); the best bread (Pain D'Avignon's sourdough boule); the best knife (carbon steel sharpened on a whetstone; can't stand a dull blade); the best button-down dress shirts (Brooks Brothers, until they got cheap and he changed to Harvey & Hudson on Jermyn Street, Portugeuse flannel; and Gitman Bros.); the best outerwear (Patagonia); the best parmesan cheese (Parmigiano-Reggiano wedge, hand grated); the

best coffeemaker (Braun, discontinued; "Kate, keep your eyes out for one at your estate sales"); the best raincoat (Burberry's khaki trench); the best doughnuts (Fleming's Donut Shack, Cape Cod, Massachusetts, now closed; still searching for a replacement); the best Maraschino cherries (Luxardo) to make the best Manhattans; Häagen-Dazs vanilla ice cream is the best bar none, especially with fresh blueberries and cut summer peaches. He'd take us to the farmer's market as a treat to buy the best fresh ingredients so I could cook recipes I found in *Gourmet*. We weren't allowed any soda, but he'd occasionally let us drink Coke with Snyder's pretzel rods because it's a match made in heaven.

My dad always said: Buy the best you can afford, because you get what you pay for. The most expensive option is overrated, flash, and unnecessary; the cheapest option is, well, cheap; and the middle option is often the best value, well-made, and does the job, nothing more, nothing less. Stop buying furniture that will end up on the curb next time you move. Save up for what you really want.

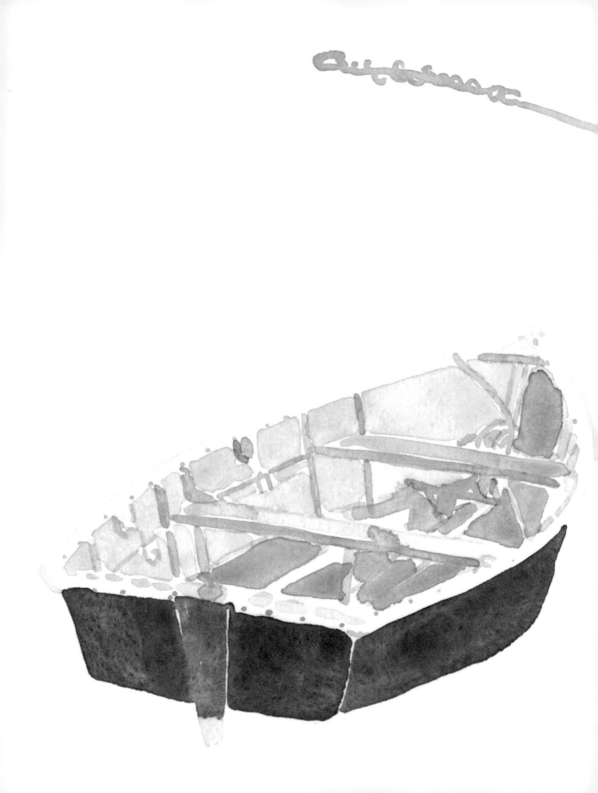

My dad loves his blue wooden skiff, which he prides himself on maintaining with his own two hands, painting it every year. He loves its small, humble shape that cuts elegantly through the water, pulled forward by a pair of wooden oars that are wrapped in leather and make audible squeaks and sighs as they rest and turn in brass oarlocks.

JANE HERMAN

Writer and editor

BROOKLYN

FAVORITE ARCHITECTURAL LANDMARK The Hollywood sign.

QUICK DESCRIPTION OF YOUR OVERALL LOOK
Tomboyish, tidy, and always in denim.

ALWAYS IN YOUR FRIDGE Butter and a bottle of champagne.

JEWELRY YOU NEVER TAKE OFF
A gold ring shaped like a thorn on my right pinky finger. Every rose…

WRITING IMPLEMENT Uni-Ball Roller fine-point pen, black ink only.

COMFORTS YOU LONG FOR Sunshine on my skin and an organized closet.

WORN-OUT CHILDHOOD TOY A stuffed poodle doll named Floppy.

FAVORITE NONELECTRICAL TOOL OR THING
Do jeans count? I need them to get just about everything done.

"FORM FOLLOWS FUNCTION" MEANS
That the most beautiful things are also the ones that work.

SKILL YOU DREAM OF MASTERING
Playing the acoustic guitar.

SNACK Medjool dates and Ruffles potato chips.

FAVORITE VIBE TO CHANNEL My own.

YOUR PEACEFUL LANDSCAPE Straight to the Pacific Ocean.

LESS IS MORE, OR MORE IS MORE? Less is usually more than enough. Joan Didion said,
"Every day is all there is." I like to use the things I treasure deeply as often as possible.

INSIDE YOUR HANDBAG
A Smythson Soho diary.

SALAD DRESSING
Lemon juice
and olive oil.

**BOOK YOU KEEP CLOSE
AND REFER TO OFTEN**
The White Album by Joan Didion.

OLDEST ITEM IN YOUR WARDROBE
A pair of Levi's Orange Tab 517s. I got them
when I was eighteen and have had them repaired
and tailored more times than I can count.

Leave Room

Like my dad, I appreciate relatable stuff, things we can all use. Good design. I see "less is more" as represented by functional items and people who work hard—like trusted friends who fulfill their promise to do what they say they are going to do—and are inviting, and make me feel human. Remember, editing isn't about cold, boring uniformity—just utilitarian basics. It's expressing your personality in a simple, unique formula. It's about turning off the noise and letting a single note shine. Don't lose yourself in an edit; leave room for joy.

The Beverly Hills Hotel

SUGAR

"Less but better."

—DIETER RAMS

PART TWO

Simplify

We don't need more—we need less. We need better, tighter, more refined. Focus on the arts of economy, efficiency, and ease. Once you're there, you won't need any more. You won't *want* more. When you curate your stuff you allow happiness into the holes you open up. Stop buying things. After all, the best things in life are not things but people, experiences, doing something, being someone—relating and interacting—it's where you take your stuff that matters. Excess is only a burden.

The first step to any transformation or change is to remove what fails—drill the cavity. Uncluttering highlights the skeleton you are working with. When you understand the structure you can build, grow, and expand outward.

Get Rid of It

I love getting rid of things. I donate; I give to friends. I get the same "buyer's high" from cleaning out the clutter. I repurpose and recycle to those who want, which makes me feel like my beloved possessions (that don't serve me anymore) are going to a good home. Instead of shopping and adding, I edit and eliminate.

My design tendency is to add only if it's necessary to communicate the essence of my message. My style, my identity, *me, Kate*, is to remove to the point where I have shown what needs to be shown, nothing more, nothing less, nothing terribly overthought or agonizing. It's not easy to create, and I make many mistakes trying to get the balance right. Sometimes it's easier to advise clients and friends than it is to do for myself, and at other times, I feel a sense of relief in having my own freedom to try every conceivable option and move stuff around until it feels right. I work at my own pace.

Love What You Use Every Day (and Remove the Rest!)

My own personal classics are the things I trust and use daily:

The Importance of White Space

When solving a design problem, you have to start at the root and begin fresh: Remove everything that's not working and start from square one. Empty a room before you rearrange its furniture; clear your closet—take every single thing out—before you edit your wardrobe. Stylish solutions result from seeing things fully, truly, honestly—bringing problems out into the light. If a house is overgrown, you must first cut back the trees and bushes that cover it, and also make sure the structure is sound, before you choose a paint color for your trim. You have to let it breathe.

Start from the foundation and work your way up and out. Style is built on substance, not on surface. In other words, many things that end up on the surface are the result of careful decisions made at the core. The negative space is as important as the positive space.

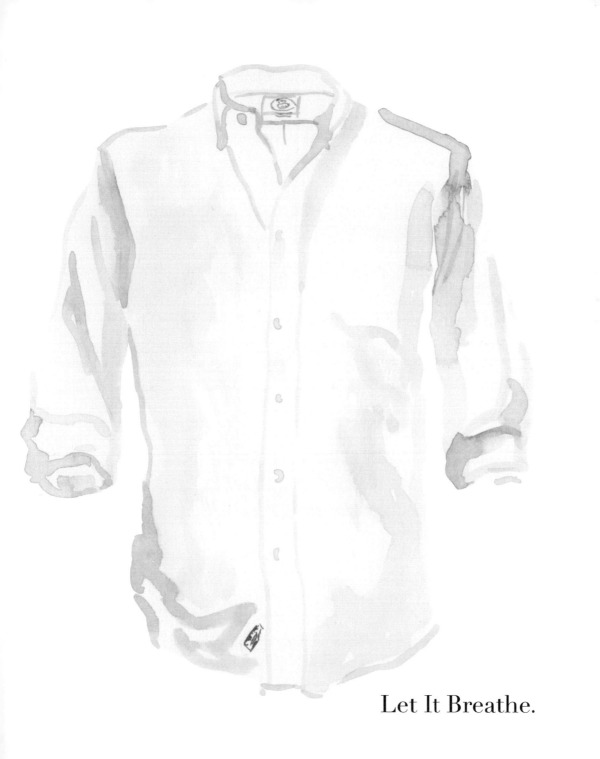

Let It Breathe.

Shop Like an Editor

A lot of people have problems with overconsumption. We hoard and shop and drown in our own stuff. Searching for meaning, we shop to self-soothe, but anxiety, overspending, and waste make us feel worse after the moment passes. I find that I actually need *less* to feel happy. The hard part of *less* is the editing: What stays, what goes, and *what goes with what?*

I am a considerate and studied shopper, which was an essential part of my styling job. I am intrepid in my search for the perfect "thing," and I love the hunt. I've spent days and weeks on styling jobs, knee-deep in wardrobes overflowing with expensive stuff that was hindering my clients rather than helping them. They couldn't make a decision. They couldn't make up their minds. They couldn't get dressed. Seventy-eight Birkin bags and nothing to wear. Closets bursting at the seams, with drawers overflowing—impossible to shut. Collections of handbags exceeding the days of the year. More shoes than one could wear in a lifetime.

My real skill involved removing huge chunks of someone's existing wardrobe and filling in the blanks with easy, useful staples they needed to make things wearable. I'd arrive with a procession of empty rolling racks that I'd fill in a matter of hours, taking "in" and "out" inventory—keep, donate, or sell. Clients would be shocked to tears by the "out" pile, how much stuff was jammed in there, failing, creating anxiety. This was emotionally charged stuff, and clients sometimes clung to their old clothes. I agreed they could keep things if they were able to convince me, beyond reasonable doubt, what they would wear an item with. The conversation would end when clients walked into their new, airy closets. The "out" rack was suddenly forgotten as the power of less cast its alluring spell—everything looked new and ready to wear. The real, honest luxury is refinement, restraint…less. It's as much about what you eliminate from your life as what you keep.

Shop like an editor: Aim to eliminate as much as possible and find the needle in the haystack, *especially* when the haystack is a pile of fabulous items. Hunt the one special piece that you'll never tire of, that you'll wear out. Browsing is wonderful, but guess what? Leave it at that. You probably don't need it.

Turn the volume down. Tune in to yourself. You really don't need much. It's like fast food: A little taste is fine, but too much will make you sick. I don't believe in fast fashion; I believe in eternal style. I believe in slow style.

Pack Like a Stylist
(This Applies to Every Day of Your Life)

I spent my late twenties and early thirties following my career, and it took me around the world many times. I traveled to Istanbul monthly for a year. I attended fashion weeks in Europe. When I first started as a photographer for Condé Nast, I flew to Paris, on assignment for *Vogue*, with six hours' notice. My heart was pounding when I took the call from my editor—I was thrilled, terrified, excited out of my mind—so I said yes and hung up the phone. In the next five hours before my flight departed, I curated my looks—seven day outfits and seven evening outfits— packed them into one suitcase along with all my film and camera equipment, and took off on time. How did I do this? I packed like a stylist.

At the time, I was assisting stylist Wendy Schecter on shoots with Annie Leibovitz for *Vanity Fair*. Wendy has a proven method for gracefully schlepping wardrobes. She hangs clothes on multiple hangers in garment bags in a specific order (size, type, kind, color) and then methodically stacks them into oversized duffel bags, which are lighter than trunks. Then she unpacks them—in the reverse order they were packed—in giant garment-bag-hugs, directly onto the rack, all zippers and hangers facing the same direction. It's pure genius.

We once styled the Huston family for the *Vanity Fair* Hollywood issue. We had a wardrobe run-through in Annie's New York studio—fifteen racks of clothing—then packed it, flew to Los Angeles, loaded two Escalades to the brim (with seats down), and had fittings with each actor before the big shoot day. Everything had to be organized and accessible. Every look was filed in Wendy's head, and I needed to be able to understand her method. We shot on location high in the desert hills north of Los Angeles and south of Santa Barbara, and we were prepared for anything—from couture gowns to tea-stained vintage Henley T-shirts. There was no time for mistakes, every reason to prepare, and every opportunity to improvise in the face of demands. I've never forgotten that shoot and how Wendy taught me to pack and unpack— and I still follow this method.

Packing is a little bit like grocery shopping with a list: It's easier if you know how many meals you will eat and what recipes you'll cook so you can shop precisely without aimless browsing, grabbing, and guessing. When I pack, I consult my itinerary of events, meetings, and dinners and plan specifically what I will wear to each one. I travel for fun and for discovery; for work; for relaxation, weddings, weekend celebrations; for important volunteer work in the field. When I travel, I want to enjoy the people and places I visit. When I land, I don't want to waste a single minute wondering what I'm going to wear.

When preparing to pack, I first try on everything that I intend to take—seeing it on helps me decide if it really feels right. Then I lay all the clothes that I *actually wear and that fit me* on my bed, in piles of looks. If I have too many looks for the same event, I choose my favorite and put everything else back. The key: I don't pack random shit.

Next, I pack each look in entirety on thin, no-slip hangers, down to the exact accessory (scarf, shoe, bag, underpinnings, Band-Aids, double-stick tape, Dr. Scholl's inserts). I zip everything into garment bags (doubles as tissue paper), fold once lengthwise from hanger to toe, and stack into a rectangular roller suitcase (or fold in thirds for a carry-on bag). Multiple looks, multiple garment bags—just like I pack for an actress's red-carpet appearance. Then I add pajamas, Dopp kit and makeup, and a comfy outfit to wear on the plane ride home. I usually pack the go-to casual outfit I wear while packing so I can feel at home in something. I carry jewelry with me, separately.

When I arrive, I immediately unpack all garment bags (zippers and hangers facing in the same direction) right into my hotel closet, shoes already at the bottom of the bags, lingerie and stockings in there, too, so I don't have to dig or go looking for anything. Loose casual pieces go in a drawer or stay in my suitcase on short trips, atop the valise stand.

I pack less, and I get more (repeat) wear out of everything I bring. I do the guesswork and planning at home, in my own closet, not in front of the hotel mirror, so I can get dressed in three minutes. This method is foolproof, and I always know what to wear.

<div align="center">

Always plan while you pack.

Always pack light!

Always be living—not lugging!

Always pack like a stylist!

</div>

My friend's dad was so thrifty that he took "packing light" to new lengths. He unrolled an allotted amount of dental floss, in a neat coil, so he didn't waste space packing the box. Every inch counts.

UNWAXED DENTAL FLOSS

ANN CARUSO

Fashion consultant and stylist

NEW YORK CITY

INSTRUMENT YOU PLAY
The piano.

QUICK DESCRIPTION OF YOUR OVERALL LOOK
Classic, clean with a European twist.

CAN'T COOK WITHOUT
Steamer basket. It just makes cooking vegetables so easy.

MOST WORN-OUT SHOES Givenchy mid-heels.

MAKES YOU FEEL COZY
Watching movies snuggled under my Hermès blanket.

FLOWERS
I love any and all—roses, tulips,
peonies can change my day.

ON YOUR NIGHTSTAND
Water, notebook, a pencil or pen,
lavender and frankincense oil.

OLDEST ITEM IN YOUR WARDROBE
A white denim Levi's shirt and a Mickey Mouse sweatshirt from high school. And pieces from when my family came over from Italy in the late 1800s. They had trunks of clothing brought over on the boat with them. I loved the undergarments they wore under their corsets that looked like cotton sundresses. I wear them around the house with sweaters. They are very Chloé-looking.

SENTIMENTAL GIFT YOU'VE RECEIVED
A gold fish necklace that was given to me as good luck before a life-changing moment.

FAVORITE ACCESSORY
Sunglasses, a good bag, and a smile!

MAKES YOU FEEL AT HOME
My duvet and sheets, my silk curtains with pom-poms.

FAVORITE ITEM IN YOUR WARDROBE THAT MAKES YOU FEEL LIKE A CHARACTER IN A MOVIE
Anything from Dolce & Gabbana.

LESS IS MORE, OR MORE IS MORE?
As a fashion person I have a lot of things, but in the end I end up wearing only a few of my favorites every day...So I am always looking for something new and editing the old so I can replace it.

FAVORITE FABRIC PATTERN
Polka dots.

DISHES
Wedgwood china.

Applicable Knowledge

The concept of a public library is one that makes me feel warm and fuzzy inside. I long for the days of stamped due dates on library cards nestled inside the back jacket pocket. So perfectly efficient and economic, libraries preserve books to be shared by all, reducing the need to shelve a copious amount at home. I love the look of a room full of books—a three-dimensional wallpaper of colorful spines soldiered together on creaky shelves filled with nooks and crannies—but it's not practical or efficient, or fair to the books unless they are cracked open and read.

The rule I use to edit my personal library of books at home is the test of "applicable knowledge." Does the book contain information that is useful? Knowledge I can apply to my life and work? Will I return to it over and again with dog-eared pages, a confetti of bookmarks, notes handwritten in the margin? Cookbooks are applicable knowledge because I prepare their recipes; photography, architecture, and art books are applicable knowledge because I turn to them for visual inspiration; philosophy and self-help books are applicable when I get lost, depressed, or confused and need to remind myself of a thing or two to keep moving forward. As a rule, I generally don't keep novels around—I lend them to friends, or I borrow them from libraries—books need circulation. Find your own measure for keeping books at bay and apply it ruthlessly. Books are meant to be shared, loved, and used—not collect dust.

Mom's Jewelry

My parents had identical gold wedding bands in the perfect width of medium: not too thin, not too hefty, each suitable for a man's and a woman's hand. My mom never received an engagement ring from my dad, and she never wore diamonds, which I think made her look both younger and more modern. She is the type of woman who wears her clothes rather than her clothes wearing her. My mom lived "less is more" without ever saying it.

Mom kept some family heirlooms in a safe-deposit box, and I loved going to the bank with her to watch as they pulled out the long, narrow drawer that held her mother's and grandmother's jewelry. My mom's mom, Granny, wore a thin gold bangle with all her grandchildren's first names and birth dates inscribed in a delicate script inside the rim. Mom wore a gold bangle from my dad with our initials CKJKGK engraved inside (she'd given him a Pennsylvania license plate with CKJKGK for our family station wagon). She wore it every day, until one day, it disappeared in the UK Eurostar security tray. For her seventieth birthday, my three siblings and I gave her a new one inscribed with our four names and "We Love You Mom." I don't think it's as good as her original, though.

I always loved my mom's simple gold bangle—along with her wedding ring, these were the two pieces of jewelry she never took off. On our anniversary, my husband gave me the most beautiful gold bangle that I'd been eyeing. I opened it and cried. "Look inside," he said. It was a bracelet so I didn't understand. "Look harder!" *CJS* inscribed on the inside rim; *KWS* inscribed directly opposite. "We'll fill in the blanks later." When Charlotte was born, we added *CKS*. I never take it off, not even for airport security.

Lightening Up

In 2010, at the height of the recession, I hit my stride as a stylist. Suddenly, there was a real reason to stop consuming. It was like when school is canceled on a snow day—the decision is made for you. Everywhere I turned there was depressing news about bankruptcy, job loss, unemployment. The glamour train had stopped.

Ironically, I felt a sense of relief. I looked at my Earl jeans—five identical pairs I'd bought in 1999 that fit me perfectly and that I still loved and wore—and thought: *These are just fine. I don't need new ones.* I looked at my shoes and thought, *None of these need resoling; they're perfect.* I was just fine with what I had. I had everything I needed, and I felt deeply grateful for what I had when so many had tragically lost so much.

I went through my storage unit in the basement of my building, which was loaded with an archive of vintage treasures and designer gifts that I'd worn in years past, and I began to sell the stuff I no longer wore. I wasn't interested in dragging extra weight during the recession. I wanted to lighten up. I wanted my vintage Pucci slip to go to a good home, and my Yves Saint Laurent Rive Gauche blouse to go to someone whose color it would flatter. My classics went into turbocharge and got me out of the recession in style.

Restraint: Thin to Fat

My tenth-grade art teacher, Elissa Factor Sunshine (aka "Mama Chic-a-dee" to her students because she was warm and loving and called her students "her chic-a-dees"), repeated to us: "Paint thin to fat, light to dark, transparent to opaque." She wrote it on the wall of our classroom: "Thin to fat." She repeated it every few minutes while she walked around the room checking our work as we learned to paint with watercolors: "Thin to fat." I remember it vividly—it's my mantra—a perfect idiom for everything I like: Thin to fat; quiet to loud. Build slowly, one element at a time, one stroke, one wash, one color. Add one block onto the next carefully, and the form is discovered. Try not to overdo it; underdo it. In cooking, start with the best, freshest ingredients, building depth of flavor gently. Add salt a pinch at a time—your taste buds don't lie.

Thin to fat is editing in reverse. It takes mindful consideration of what you're doing. Use the minimal material that will sufficiently do the job. Low-fi. I think of a slim, sharp chef's knife swooshing through a juicy tomato. When I buy furniture, clothing, tools, I think: *Thin to fat.* If something needs to be sturdy, I get the "fat version," but if something smaller will get the job done—with the same strength—I select that option because it leaves more space to work, for parts to interact, to breathe. It's less wasteful and it saves space. Economy makes for good design. Physical and emotional space is such a luxury in life—it's better to start with less and build as needed.

I'm uninterested in things that
are incredibly complex. The
simple things are more impressive
to me…the pots of rice.

—MICHAEL SOLOMONOV,
CHEF AND OWNER OF ZAHAV RESTAURANT

The Uniform That Doesn't Conform

I understand the power of an efficient uniform. I've been that person who stares at a closet full of clothes but has nothing to wear and no time to figure it out. As a stylist, my job is to help people find the mix that works for them and then fill in all the blanks. But sometimes it's impossible to turn that style eye inward. Enter my uniform.

Different things work for different people, so as a rule, your daily uniform doesn't have to fit a particular mold. It can be stylish, colorful, and diverse, conforming to your needs and your body. Not everyone need follow the same principles, nor do the same pillars of style apply to all bodies.

Style icons like Lauren Hutton, Ali MacGraw, and the late Steve Jobs and Coco Chanel are iconic because they all wore a uniform. Their individual wardrobes exhibited personal restraint and consistency, and their style spoke volumes. They stuck to what suited their individual body, lifestyle, and vision. Their wardrobe staples were their limited palette. Find the fabrics, colors, cuts, and shapes that work on you. Then repeat-wear and rely on them without a second thought. Know that they are yours to trust.

Learning the power of a good, personal classic can help in the pursuit of a uniform that doesn't conform. Your basics can be reinvented as many times as you'd like if you creatively assert yourself and style, push boundaries with details—perhaps adjust your hem or wear an unusual shoe or sexy stocking. You don't have to change radically or overthink your outfit every day, wasting hours of time. I encourage you to have a uniform that you stick to—with consistent colors, hems, heel heights, and fabrics that work together. Just make sure you have fun defining the details, and make them part of your own personal uniform. It can be you—simplified, streamlined, easy, and classic.

The Uniform That Conforms to Perform: Military Garb

Militaries around the world have introduced volumes of vernacular style that we take for granted because it has become so mainstream. Military uniforms have effectively transcended their original use and permeated the world of everyday fashion. Once protective, functional, recognizable body coverage, they've entered the style lexicon, becoming classics in their own right. Army green, camouflage; full-dress whites; neat rows of brass buttons marching across the breast; peacoats, berets, striped shirts, sailor pants; bomber jackets, aviators—all classics by design that once efficiently told the world what a person did—are now part of the fabric of everyday life. You can find affordable basic pieces at your local army and navy surplus store.

ETHAN LEIDINGER

Investment manager

NEW YORK CITY

INSTRUMENT YOU PLAY Trumpet and baritone horn.

MOST WORN-OUT SHOES Brown Belgians with a black bow.

PRODUCT YOU'VE USED SINCE HIGH SCHOOL Acqua di Parma.

WRITING IMPLEMENT Fine-point Sharpie.

WHAT YOU BRING HOME IN YOUR SUITCASE WHEN TRAVELING ABROAD
All the hotel's bathroom products.

MOST FUNCTIONAL ITEM YOU NEVER TIRE OF Vintage Gucci shoe horn.

OLDEST ITEM IN YOUR WARDROBE
Patagonia fleece (Sacagawea print).

RAZOR Truefitt & Hill.

FAVORITE ALBUM SINCE HIGH SCHOOL
Madonna: The Immaculate Collection.

DAILY BEVERAGE Earl Grey tea.

COMFORTS YOU LONG FOR A baby.

LESS IS MORE, OR MORE IS MORE?
Less, unless you're talking about bookshelf clutter.

FAVORITE VIBE TO CHANNEL
Steve McQueen. I wish I could channel that.

THINGS YOU USE OCCASIONALLY AND TREASURE DEEPLY
The right side of my brain.

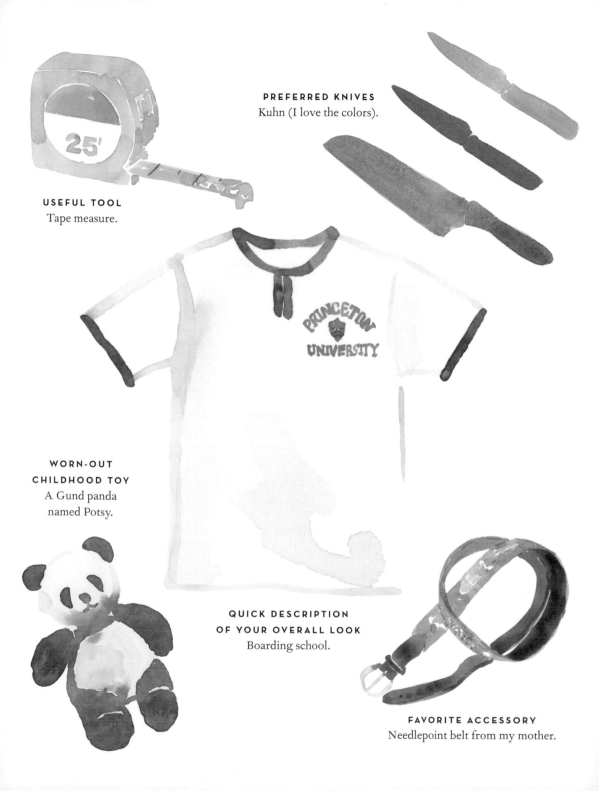

PREFERRED KNIVES
Kuhn (I love the colors).

USEFUL TOOL
Tape measure.

**WORN-OUT
CHILDHOOD TOY**
A Gund panda
named Potsy.

**QUICK DESCRIPTION
OF YOUR OVERALL LOOK**
Boarding school.

FAVORITE ACCESSORY
Needlepoint belt from my mother.

You Don't Need It and You Won't Miss It

Most things we want, we don't need. Let's be honest: We don't need much. We fall in love with stuff, but do we really *need* it? When we shop, we rarely find what we actually seek—we find what's available at that exact time—but we feel we have to buy something to fill the void, complete our task, check the box. That's when you need to run! If you're unsure, leave the store as fast as you can! (Stores are designed to inspire spending.) Sample sales used to have me guilt-buying, until I learned to say to myself: *Get out of here, now!*

Take the Phone off the Hook

Growing up, we were expected to participate in our family. Nature was important. We lived near the Wissahickon Trail and Creek (nearly twenty miles of woods, a green ribbon that weaves its way alongside a shallow river through residential and urban areas). We played outside with ducks, bunnies, cats, and a Shetland pony named Rusty, which Mom would occasionally lead to Germantown Avenue, tie to a parking meter, and do the grocery shopping—hanging shopping bags from the horn on his western saddle.

We had an upright player piano in our entryway, with music rolls of the entire classic catalog of musical and show tunes ("Over the Rainbow"; "My Favorite Things"). When friends came over we'd all end up pedal-pumping out the music and belting out songs to the little light blue lyrics.

My siblings and I helped cook holiday meals. I was doing my own laundry by fourth grade. Up until I was fourteen and my parents separated, the six Schelters ate family dinner around a fifty-four-inch round table every night of the week. We unplugged the phone by pulling the wire from the base so it didn't make the *dat-dat-dat-dat-dat* phone-off-the-hook noise. This sent a lasting signal to all of us that there was nothing

more important in that moment than the six of us sitting together and talking. All attention was on us, with no interruptions.

Take the phone off the hook. You're missing the good stuff.

Progress, Not Perfection

Sometimes you need an abrupt disruption to reenergize your creativity. Having a baby was that invigorating moment for me. I had been terrified that my career would end when I became a mother, that my business would collapse. Instead, the opposite was true. I reinvented my world, and myself.

As a new mother, I inched my way back into work after maternity leave. I found it utterly discouraging at first —I just could not yield the same amount of work. My only solution was to repeat one thing to myself over and over again: *Progress not perfection; progress not perfection; progress not perfection.* Slowly, I began to learn how to make decisions faster—emphasizing solutions or deal-breakers to keep momentum. I got stuff done.

Now I know that completion is more effective than total perfection. Make progress. Get as close as you can. I now realize how much time I wasted pre-baby. I would agonize over decisions, hem and haw on making everything perfect. So much energy spent treading water! Every day I remind myself to move forward and keep my momentum. To simplify. To be decisive. It's as though I am more productive with less time—because I don't have a choice! A mother has no time for mulling over a decision in her belly; she goes with her gut. A mother understands efficiency. Becoming a mom has taught me to trust my instincts and my routine, and that extra stuff ends up being a hindrance. There's no time for it and no place for it. It malfunctions in your face. You must pare down to what works every time.

What Makes You Beautiful?

Just the right amount of grooming: not too much, not too little. The Clinique foundation and blush that you bought when your mom first took you to Saks when you turned sixteen—the color is still perfect for your complexion—free gift with purchase! Sunscreen. A blow-out for an important meeting and bedhead for black-tie. Not washing your hair after a day at the beach. Occasional plucking and trimming. A once-a-year or biannual haircut. Swiping a fresh lacquer across your lips, curling your lashes for a night out, choosing between a smoky eye, a perfect line on your upper lid, or a pop of color on your mouth, but never all three together. Tousled hair, leaving yourself alone. When your daughter says so.

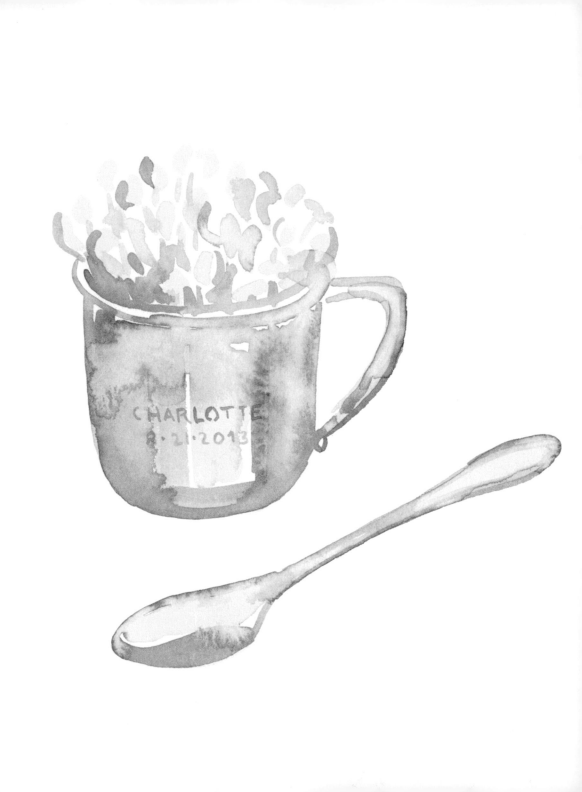

Mastering Motherhood Efficiency

Babies, pure, simple, clean, and new, are born a perfect package. But they come with a lot of stuff, even when you're an "absolutely no extra baby stuff/all organic/only wooden toys/cloth diapers" cliché parent like moi. Babies seem to expand outward in waves. As a mom, your own stuff must be reachable. That sweater in the bottom of a box, behind three other boxes, on the highest shelf in your closet will *never* be worn again. Ditto for the dress with the stain that needs to go to the cleaners. A mom's stuff must be in good working condition, usable with one hand while you carry your adorable offspring in the other, smearing snot or vomit onto everything like a liquid static cling. Even the minimalist parent experiences spills, spit-up, dirty laundry, toys, bottles…everywhere, like Damien Hirst has made spin art out of all your belongings in your living room. Like criminals have raided the place. For me, tidying up is a small pleasure, a huge sigh of relief, a thing I can do to make myself feel better.

And, so, it's Charlotte—in pregnancy, birth, and every day hereafter—who teaches me to do more with less. I am dedicated to any scheduling she and I can follow: help with child care, naptime, bedtime. (Rest fixes everything.) I no longer need or am tempted by the latest and greatest clothing and accessories in the stores, the fashion parties, or the social circuit. I saw that I already had everything I needed as a mother. As long as it was reachable with one hand. I rely on what I love, use, and trust and keep moving.

Pregnancy ~~Style~~

When I was pregnant with my daughter I learned the power of doing more (growing body size) with less (shrinking wardrobe options) because I didn't want to spend time and money on a maternity wardrobe that I didn't like. As a stylist, I was so confused. I knew my wardrobe inside and out and loved everything in it, yet suddenly it didn't work the same way anymore. It was like not knowing myself. I'd lost control over the way I knew how to express myself, a skill that I'd refined over many years. So I did what I always do in life when I can't find a solution: I waited. I lived in leggings, my husband's button-down shirts, blazers, and riding boots (and, uh, sweatpants).

Eventually, I *had* to do something, so I took everything—everything!—out of my closet that did not fit me and moved it to a spare closet (justified storage). What remained was what I could see, what I could reach, and what I could wear, now. Sure, I had less options in front of me, but every option worked, and dressing was easy, and I could wear my normal clothes. I wore the same string bikini I wore on my honeymoon, only fifty pounds heavier. It did get repetitive, but I never had any doubts when I got dressed and I never wasted any time. It was the ultimate utility edit. I learned to depend on my choices, and I was really grateful for the few items that really performed, that took me through my entire pregnancy, comfortably, with style. Efficient wardrobe choices, efficient EVERYTHING, gives you freedom. I have never looked back.

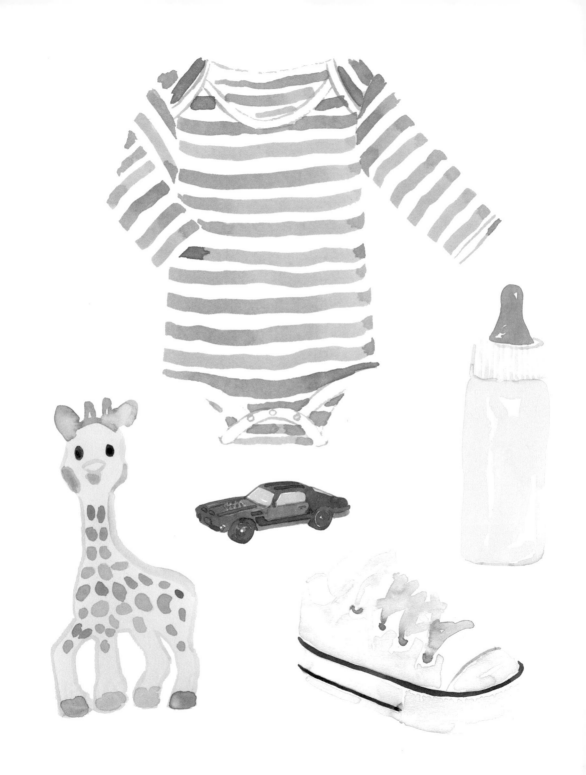

Simplicity by Design

Good design makes for powerful iconography. Slow style in the face of fast fashion is classic by design, refined, straightforward, and gracious. Along with my three-year-old daughter I'm immersed in the bold, graphic world of children, and it's wearing off on me. When we play with toys and read books together I can see what she responds to—she points to images that jump off the page and identifies basic shapes. A yellow circle is a duck; a red rectangle is a car. Toys with the plainest shapes remarkably convey nuanced concepts. We get lost in Richard Scarry's illustrations of rabbits riding around on mopeds in double-breasted suits; the bedroom décor in Margaret Wise Brown's *Goodnight Moon*; the accessories in *Pat the Bunny* by Dorothy Kunhardt; Ludwig Bemelmans's *Madeline* with neat rows of girls in pinafores and yellow hats; Maurice Sendak's soft quality for capturing dreams and a child's imagination. The classic books and toys that I like are not overdone and they convey meaning simply and clearly—they are playful, specific, and they don't talk down to their audience.

Kids: The Original Style Sponges

Children are not born with an instinct to conform. They are creative. They start from zero: pure, honest, uninhibited version 0.0. They are born with a sense of wonder, an instinct to play, a curiosity to create and experiment. They have a natural freedom—they can follow their hearts and their passions (even though they are too little to name those) and daydream and take their time. They are completely original. They know how to mix and match and point to what they love. They are not afraid to make mistakes.

FRANCES TULK-HART

Photographer and painter

NEW YORK CITY

FAVORITE TOOL YOU NEVER TIRE OF
My 35 mm film cameras (Contax T2, Contax T3,
Yashica T4 super D, Pentax) and film (Portra 400).

QUICK DESCRIPTION OF YOUR OVERALL LOOK
Tomboy.

CAN'T COOK WITHOUT
Wooden spoons.

POTS AND PANS
Iron skillets, Le Creuset.

MOST WORN-OUT SHOES
Green Dunlop shoes (worn when I was a teenager).
I graffitied all over them and wore them every day
and loved them so much. One night when I was staying
over at a friend's house her dad threw them away.
I was pretty devastated!

EVERYTHING GOES BETTER WITH
Irish butter.

**WHAT YOU BRING HOME IN YOUR
SUITCASE WHEN TRAVELING ABROAD**
Mugs saying where I have been.

WRITING IMPLEMENT Pencil.

INSTRUMENT YOU PLAY
My voice.

SENTIMENTAL GIFT YOU'VE RECEIVED
Songs my husband has written for me,
jewelry, and books. My mum wrote me a poem
for my birthday that meant a lot.

SKILL YOU DREAM OF MASTERING
Flying (my granny flew planes during the war).

SHOE OBSESSION
I don't like shoes.

WRISTWATCH
Nope.

MAKEUP Not fussy.

FASHION IDOL
None.

OLDEST ITEM IN YOUR WARDROBE
Leather jacket.

FAVORITE DISCOVERY
Watercolors.

PREFERRED KNIVES
Sharp ones.

MAKES YOU FEEL COZY
My husband, my daughter, cold air, smell of
wood fire both outside and inside a house,
blankets, and wine—all together under one roof.

YOUR DAILY UNIFORM
Jeans, desert boots, T-shirt,
sweater, beautiful coat.

FRAGRANCE Coco Chanel.

**ITEM PACKED IN YOUR
SUITCASE—ALWAYS**
Mascara, hair dryer, and brush.

Look Up

I have spent every summer on Cape Cod since I was born. I grew up around New Englanders, surrounded by four seas (the Atlantic, the canal, the bay, and Nantucket Sound) on the shores of the Cape. Cape Cod, with its sea air, its wide-open sand flats, its flat blue skies, and its '80s radio stations, is an important part of my soul. No matter where I am living, I journey back each year. It has been a consistent element, like my family, in my life. It's an automatic reset button for me. It's where I go to tune in to myself, my family, nature, and sports; and shut off my phone and neglect to check it entirely. (Call the landline if you need to reach me.) Part of me loves the landscape: the charming architecture of a saltbox house, a modest barn, a stone wall with no mortar. The rest feeds on nostalgia: my sisters listening to Fleetwood Mac's *Rumours* in their bedroom on the pastel butterfly sheets, strawberry Four Seas ice cream in Granny's porcelain dishes, painted shells, native stone front steps with a hand-forged boot

scraper, wood fisherman buoys, red wagons, yacht club burgees hanging from the rafters in the garage, my mom's Dr. Scholl's clogs and the blue bandanna she wore in her hair when she was boating, Jennifer's bandeau bikini she wore windsurfing, the gentle high-pitched bounce a Ping-Pong ball made in the clubhouse, sand in the crotch of my bathing suit after a day at the flats, penny candy, bikes with wicker baskets and rattraps on the back to hold your damp towel, badminton lobbing competitions with Graham in the backyard, the Yankee thumb-spring latch on the bathroom door...

Whether you're an inherently stylish person or lack a fashion pulse all together, it is imperative to spend time in a place where style stops—trends vanish and have no relevance, and material culture is moot. Because that's who you are and what you know. That's exactly where your style starts.

Low-Fi, High-Performance

When I was twelve, I went on the *Dauntless*, a thirty-five-foot sloop that belonged to our friend Mr. Tim Coggeshall (or "Mr. C.," as he had us call him). During the summer, he transformed the boat into a tiny informal youth camp of sorts, at which we learned to sail by jumping in, climbing aboard, hoisting the sail, and taking the helm. There were six of us, and we sailed the boat ourselves, twelve- and thirteen-year-olds, under Mr. C.'s instruction and supervision, and chartered her around the Cape and islands for one week. We took turns cooking meals, navigating, climbing the mast, and swimming under the keel or grasping a halyard with wind in the sail and towing ourselves in the water off the stern for fun. I won't pretend that I'm a sailor—that family gene skipped me—but I remember the immense sense of trust that Mr. C. had in us, mixed with utter freedom and responsibility, and how much fun we had climbing all over the hills of Cuttyhunk Island, barefoot in bathing suits in the pouring rain, and rowing ashore on Martha's Vineyard with the freedom to run around and buy penny candy if we wanted to.

A retired teacher at an independent school with four daughters of his own, Mr. C. is still quite a character with a capital C: tall, lanky stature with a massive wave of white unruly curls, always smiling ear to ear, squinting in the bright sun, with scrapes and bruises up and down his suntanned arms and legs. He cut a distinct image: button-down green flannel shirt, rolled to the elbows, with lots of paint splotches and stains; dark corduroys or L.L.Bean canvas shorts with the occasional fray or tear, belted with line tied in half a bow knot or a leather-and-canvas belt; hands grasping the shredded handle of a decades-old, navy-faded-to-a-purply-light-gray L.L.Bean boat and tote bag (filled with boat tools and a homemade tuna fish salad sandwich); all grounded in honking New Balance sneakers. He is the type of man who teaches how underwear can be turned inside out and worn twice while

Wafts of
mildew
included.

True Yankees wear the same brands they've always worn, goddamn it!—Beans, Lands', Brooks Brothers ("B squared"), Patagonia, Carhartt—that stock their reliable classics.
Note: There is exactly zero differentiation between women's and men's attire, except maybe a bra.

CLASSIC STYLE

your other pair is drying from the wash (dunked overboard and hung to dry from the boom). Mr. C. says, "I would never sew a button, but I'd sew a sail. If a button comes loose, use a safety pin."

Clothes, to a salty New Englander, are a second skin, merely a barrier to provide protection and performance in inclement weather—Nor'easters! Blizzards! Hurricanes! Sun! High seas! New Englanders are crusty Puritans, worn-in souls, proud Yankees covered in their DIY battle scars—lawn mowing, garden weeding, gutter cleaning, house painting, furniture refinishing, hull scraping—life's great pastimes and pursuits that you'd never pay someone to do for you. You roll up your sleeves and get to work. Yankees don't believe in buying fancy new clothes, because the clothes they buy are investments that ought to last from college to the grave. You keep the same clothes for decades because they don't go out of style—style is irrelevant if they function and perform. If their life span falls short, say, if the sole peels off from your shoe, you wrap duct tape around it and keep on. If a fabric wears through, you patch it. No big deal. Carry on. *Worn-in* is the look, the unspoken code, the working key that unlocks the definition of classic character.

If you want to get a head start on this *worn-in* process, drench your shirt in seawater and leave it to dry on the clothesline for the entire summer—salt hastens the fading. For your jeans, paint the entire house in them, but don't wash them. If you want to test-drive your rain slicker, haul your boat from the harbor in a sixty-knot gale. As long as these items last your lifetime, all is well.

SALT OF THE EARTH

Foul-weather gear: Yellow slicker, overalls, wide-brimmed fisherman hat.

Made by hand, finished by machine.

Electricity-free: BYC "Electronic Devices Strictly Prohibited" sign.

Stanley thermos: Make modest meals at home, and pack your own lunch.

Meals: Homemade, never catered.

Cape Cod potato chips.

No-fail transport: Boston Whaler.

Cornflower blue pajamas with navy piping.

Gold and green.

Leatherman tool, aka "a wicked good tool."

Yellow Sony Sports Walkman with tape cassette.

Sixteen-plus-year-old cars: bought outright;
never leased; impossible to service due to rare parts.

Station wagon with stickers on the rear window aka
"the Family-Mobile," (remember when all your friends
and everyone in town knew you by your car!).

Ceramic dishes, never plastic or paper.

Granny's dishes and Great-Granny's silver, used regularly.

Decant the ketchup and light the candles for dinner.

Cheese ball "dip" as hors d'oeuvres.

Piano in the living room, not perfectly tuned, but it will do.

Frugality.

No phone or book allowed at the dinner table.

Deadhead your own rose garden.

Soggy bread sandwiches—because they were packed
hours ago for a picnic and the tomato and
cucumber (from the garden) sopped the toast.

Trust breeds loyalty.

Your favorite wheels: A car that is at least seventeen years old parked in the driveway, engine painstakingly rebuilt by *the* one mechanic who can, because they don't make them like they used to; a labor of love.

Jaws ruined swimming for me. It was filmed in Cape Cod and I have had a shark phobia ever since I was little. I won't swim alone in the ocean.

WELLFLEET DRIVE-IN THEATRE

JAWS ENDS SUN

FLEA MARKET SAT SUN

Friends School

My siblings and I were all "lifers" (kindergarten through twelfth grade) at Germantown Friends School, a Quaker school with a strong emphasis on humanities, creativity, and art. On Thursdays, the school (students and faculty) attends "Meeting" together, sitting in silence for forty minutes in the landmark meetinghouse built in 1869. The building is hollow like the belly of a whale, one open room, no pillars interrupting the vast space, with a double-height ceiling, stark white walls (no art), tall, narrow windows with putty-colored trim and shutters. The smooth unfinished-wood benches have faded sage-green box cushions, and occasionally creak as you shift in your seat. The architecture is unnamed by a style. It is plain and true; elegant and restrained; peaceful and poised—unpretentious.

Beautiful in its simplicity, the meetinghouse doesn't jump out at you like a Gothic cathedral with boney buttresses does. It's calm, quiet—stoic. Its architectural purpose is to project the silence emanating from its community and amplify those who occasionally feel moved to speak briefly. The meetinghouse magnifies quietness while we sit on the same level, in rows of benches facing (each other) in four directions. It's the definition of "Let it breathe." The negative space (peace) is as important as the positive (speaking).

My family history at Germantown Friends (twenty-three uninterrupted years of Schelters), along with the school's philosophy, had a tremendously deep effect on me and my core values. I had an extended community of students and siblings, friends and their families, and faculty there. My Friends school education—its ascetic aesthetic—continues to influence all my choices in life, as well as everything I practice and believe in today. The school motto, "Behold, I have set before thee an open door," represents an open mind and unlimited possibilities. They taught neither a look nor an aesthetic, nor a visual standard nor a code. They taught me originality, diversity, honesty, courage, and tolerance—the tenets of my education as well as my life's work—and simplicity.

QUAKER MEETING GUIDELINES

Quakers are called Friends. Friends and their guests attend meeting. Whoever wishes to speak may stand up in their place and share their thoughts out loud. Anyone is welcome to speak for a short time. A message is usually brief, and it is not expected to be polished or conventionally eloquent as long as it is sincere and intended for the entire group. Some time should elapse before there is another vocal contribution, to give people time to reflect on what was said. The silence is concluded by the shaking of hands between friends.

In school we called our teachers by their first names. It was informal and a lot of teachers dressed casually. A wool kilt here, a Patagonia pullover there, a brown corduroy jacket with leather elbow patches. My senior history teacher secretly smoked a pipe in his office. There were a lot of gray New Balance shoes running around campus. I think it was the teachers' default shoe setting. Dan taught PE class and sex ed in them; Florence wore them with a kilt and cable-knit tights while teaching us about ancient Greece and Charlemagne; Don wore them while he banged out ragtime on the piano. At the time, I didn't get it.

Simplicity works.
Keep it simple.

"Do more with less."

—BUCKMINSTER FULLER

Reinvent

Reinventing Myself,
My Clothes, My Career

Classics can evolve, as you do, over time. Reinvention can be literal (like hemming a dress, reviving a find from an estate sale) or about reinventing your approach to fashion and style (like how you dress), or about reinventing yourself, your world, your mind-set, your skills, your passion. Stay on your toes, and you'll grow like a sunflower leaning toward the light.

Reinvention is an uncanny theme that runs parallel between my career and my closet. Both are roundabout journeys that go upward, sideways, downward, backward, forward—like a gnarly tree of intertwined branches. Close up, you can see the connections between things—timing, people, hard work, and a bit of luck—like it couldn't have happened any other way. While the journey looks seamless in hindsight, it's anything but. The process of reinvention is active, messy, and bold—cutting and pasting, mixing and matching, breaking and mending. I like to work with what's immediately around me. I bump up against people and materials and the inspiration sticks. A career is an intrepid expedition into the world *and* an odyssey into the soul.

How do you cut and paste? Put stuff together from what you already have, see what works, determine what's missing, and then fill in the gaps. I like to try to retrofit, reinvent, or repurpose first.

Dress-Ups

My earliest awareness of passion was getting lost in my own imagination. Time didn't exist when I was making things. It stood still. When I was creating and being myself completely I was in the zone. I never wanted it to end. I felt no need to check the time, ask what was next, look at what my neighbor was doing. I was completely immersed in play and in the moment. Focused. It's no accident that I do what I do now.

Playing dress-up was my thing. We had a wooden chest full of clothes from my mom's aunt Kathleen (a concert pianist) and tattered odds and ends. We reinvented ourselves every time we opened the lid. I could create any character and assemble any combination of pieces. Every day after school, we built characters, outfits, stories, narratives, dialogue, and staged photo shoots with disposable cameras (to mimic what we'd seen in magazines)—all from imagination. We made dresses out of old fabric remnants lying around my mom's interior design office.

Most of the toys I played with growing up were not toys, they were just normal objects without rules. It was up to us to put them together, make the rules, invent the characters, get our siblings or friends involved, activate our imaginations, and get creative. The land of make-believe was everywhere. A new life was hiding in a wooden chest of dress-ups; you just had to open it and start putting things on.

I liked to dress up with two different shoes, one on each foot. The look was one part Granny's green Pappagallo flat (remember Bermuda bags with their wooden handles and button-on covers so you could match your shoes?), one part Candie's slide a là Sandy in *Grease*.

Extra credit: Tying
the laces into little
orange coils. This
allows them to
become slip-ons.
Permission granted
to step on the heel.

Hand-Me-Downs

I've always been a scrappy fashion forager. As the youngest, my three siblings and their older friends would give me garbage bags full of trendy treasures they'd outgrown: Guess jeans, Esprit sweatshirts, Ralph Lauren polos, Benetton rugby jerseys. On the one hand, I was given all the "trendoid" material (my dad's word)—stuff that my parents refused to buy. On the other hand, my siblings passed down clothes that had been previously worn by one or all three of them—traditional, basic stuff, with some very pretty dresses my mom had sewn and smocked. I would ask for shoes for my birthday and place the J.Crew catalog, dog-eared with items circled in pen, on my mom's pillow to fill in the gaps. I remember the world stopping when I got cowboy boots in ninth grade; L.L.Bean bluchers (with rolled laces) in seventh grade from the store in Freeport, Maine; the modern Prada heels my sister Kristin bought me in Italy as a graduation gift from college; the Adidas Sambas my brother had, that I wanted, too; the turquoise Converse Chuck Taylors that I tie-dyed with bleach in the bathtub.

I had no dress code or uniform in school, and it was fun to experiment with clothes (although I was mostly "dressing down," wearing outdoorsy clothes with a preppy slant like most kids). From OshKosh B'gosh overalls, Tretorn sneakers, and L.L.Bean boat and tote bags, I dove into a more risqué territory with a Body Glove bikini or fingerless lace gloves and a mesh shirt from the Zipperhead boutique on South Street. I religiously read my *Sassy* subscription, cutting collages from every spare magazine I could find to make posters for friends to wallpaper their rooms. My mom called me "Fashion Passion" and surveyed my outfits with delight as I headed out the door to school every morning.

Experimentation gave me great confidence to stretch my identity. I made hand-me-downs my own by learning to be resourceful, to mix and match.

Occasionally, I raided the designer discount racks at Filene's Basement (pronounced with the elegant Italian accent "Fee-len-aise" in my family) and combined them with my latest thrift store finds. I was curious and willing to go out on a limb, to try, to succeed, and to fail. I had nothing to lose. Today, when I'm wearing used clothes—found objects, designer runway samples, thrifted treasures—I tend to be less precious and have more fun in them than in brand-new things that I've bought (and am afraid to wear because I might stain something). I'm more open to interpretation, repurposing, and experimentation.

One Girl's Toiletries
Are Another Girl's Treasures

When my sister Kristin graduated from college in 1991, we all
went to celebrate, and I got to meet her roommates. I was in
heaven, a high schooler surrounded by cool college girls. She
showed me around her dorm, which was empty except for the
graduating seniors. Most students had packed up and left for
the semester, and so I nosed around, peeked into rooms, and
was shocked when I saw the gobs of leftover stuff: cool
clothes, half-full bottles of Paul Mitchell shampoo, Nexxus
conditioner, Crabtree & Evelyn cream, Cacharel Anaïs
Anaïs perfume! I couldn't believe my eyes. Dozens of
designer products left behind because students didn't bother to pack them.
Kristin explained that they were all going to be thrown out by housekeeping. No way!

I ran around my sister's floor like a time-lapse shopping spree, gathering as many of
the trash treasures as I could carry. I made a hammock out of my shirt to hold my loot
and condensed like brands to maximize bottle space, filling my suitcase like a Rubik's
Cube. Back at home, I unpacked the best designer shampoos, creams, and beauty
products with delight. The stock would last for the next two years and was light-years
beyond the Pert Plus, Pantene, and Finesse that I normally used from CVS.

Limited Resources,
Endless Possibilities

Growing up, I was used to having limited resources. Style, to me, meant putting things together in a new way—it was more about how I assembled preexisting clothes than about what I bought. Customize and personalize. I sewed pretty patches, from my mom's Clarence House and Brunschwig & Fils fabric samples, all over my Levi's 501 button fly jeans every time they ripped. The more worn-out, the better. With a needle and embroidery thread, I sewed my initials on the back pocket freehand; I sliced sleeves off of sweatshirts; I tailored my own jeans; I scissor-shredded a "Hollywood" tourist T-shirt into spaghetti strings with beads, like the ones I'd seen on Jamaican postcards. I wore Multiples scarves (totally '80s) as body-con mini-skirts to school dances. I broke three sewing

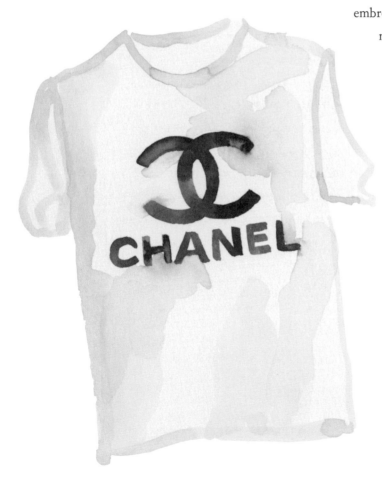

machines with the lead-foot enthusiasm of a teenager who'd just passed her driver's exam. I once cut six necklaces to scrap for the beads to make one long one. I made bracelets out of buttons, skirts out of curtain valances, a miniskirt from two navy bandannas safety-pinned to each other, and sandals out of purple ribbons wrapped around my toes and ankles to match a dress for a garden party in the grass.

When I was much younger, despite how much I begged for a Cabbage Patch Kids doll with a plastic face and its official Xavier Roberts birth certificate, Mom bought me an all-fabric, plastic-free, handmade one, which was far superior in her mind. After that, I found a pair of L'eggs panty hose in her drawer and stuffed it with cotton balls and sewed it to make my own version of a Cabbage Patch Kid, which actually looked more like a voodoo doll. I made Jams shorts at my next-door neighbor's house after school. My wardrobe was a constant creation: a mixture of hand-me-down trendy threads, reinvented traditional staples, oddball thrift store orphaned gems, something from a yard sale, and coy attempts at designer luxury, like when I bought a knockoff Chanel T-shirt, with the black logo of interlocking *C*'s, on the street in NYC during a class trip to the Met. This was my process of arranging things in my own way. Your wardrobe should be a collection of many years, many resources, many places, with your own mix of references, time-traveling, and things that work for you. Style is not a one-stop shop.

One Hundred Safety Pins

Around the holidays, when I was eleven, my mom treated our family to an evening in New York City: the Helmsley Palace, a Broadway show, and dinner at the Rainbow Room. A *real* Christmas treat. As a family of six, we didn't eat at restaurants, and we didn't stay in hotels, let alone a fancy one, but my mom wanted to do something special as a gift to us—to have an *experience* rather than more stuff. I'd packed my ankle-length crimson damask Laura Ashley dress (that I'd worn to ballroom dancing classes) for the occasion. I'd had a self-imposed feeling that I had to dress up when we came into NYC. I took it out of my bag to hang in the closet and as I looked at it—fancy and beautiful—I had a subtle feeling that it was not *me*. The dress was too traditional and I was slightly embarrassed to wear it, but I didn't have a single other option. I had zero cash. Besides, I didn't know my way around the city.

I picked up the room phone, dialed the operator, and asked where I could find one hundred safety pins. "Please hold," he said. Soon there was a knock on the door, and there stood a concierge with pins on a silver tray. Wow. I grabbed my dress, turned it inside out, and took the bottom hem, gathered it by eye, and pinned it to the waist seam at every half-inch. It took about fifteen minutes. My family asked what I was doing on the floor. I went into the bathroom, turned it right side out, put it on, and modeled my new bubble dress (ta-da!) for my family. I was ready for a night on the town!

Cut the Hem and Start Again

I once hosted a black-tie party at the CFDA Awards (the Oscars of fashion) at the New York Public Library on Forty-Second Street. I wore an ethereal orange floor-length gown of silk chiffon that I had borrowed from Hermès. It was the exact dress Kate Moss had worn (barefoot and riding a horse bareback) in *Vogue*. At five foot ten, I needed platform heels to keep from tripping on the hem. The afterparty, held at the nightclub Bungalow 8, was packed with every bold-faced name in fashion. As we celebrated, my gorgeous dress dragged across the floor and puddles of spilled drinks. Unbeknownst to me, the hem soaked up the stiff cocktails. I woke in the morning to find the gown had shrunk three inches. The liquid had dissolved the fabric completely! The drinks ate my dress. (Remember what Mary Bradley said? *Nothing good happens after midnight!*)

Horrified, I immediately called their PR department, explained what had happened, and apologized profusely. I was freaking out, offering to send it to Madame Paulette, the best cleaner in the city, or to pay for the damage (which I was certain I could not afford). They graciously said not to worry, that it would be sent to their seamstress, hemmed and worn again; no problem.

When I told this story to a designer friend of mine, he said he was happiest when a dress came back from a shoot destroyed—gowns worn by models diving into swimming pools fully coifed—because it was the one they really loved and wanted the model to wear. The one that was lived in. Anything can have a second life.

JULIA CHAPLIN

Author, designer, Gypsetter

BROOKLYN

FAVORITE HOTEL
Hotel Raya in Panarea, Italy.

**QUICK DESCRIPTION
OF YOUR OVERALL LOOK**
Minimal messy.

SUNGLASSES
Vintage late '70s / early '80s
Vuarnet ski glasses.

**WHAT YOU BRING HOME IN YOUR
SUITCASE WHEN TRAVELING ABROAD**
A piece of furniture, checked as oversized luggage.

ITEM PACKED IN YOUR SUITCASE—ALWAYS
The vintage kanga sarong I bought in Nairobi, Kenya.
I use it as a bathrobe, skirt, shawl, and security blanket.

INSTRUMENT YOU PLAY
I sing, badly but often.

ALWAYS IN YOUR FRIDGE
Grey Poupon mustard.

BOOK YOU KEEP CLOSE AND REFER TO OFTEN
The Electric Kool-Aid Acid Test by Tom Wolfe.

**PIECE OF FURNITURE YOU
REALLY LOVE AND USE EVERY DAY**
1970 Mario Bellini for B&B Italia
sectional sofa. Sent from Sicily.

ON YOUR NIGHTSTAND I don't have one.

INSIDE YOUR HANDBAG
Lip gloss, frayed old business cards
from strange strangers.

FAVORITE ARCHITECTURAL LANDMARK
Roden Crater by James Turrell.

MAKEUP
Bobbi Brown lip gloss, NARS bronzer stick.

SKILL YOU DREAM OF MASTERING
A good singing voice and hip-hop dance moves.

OLDEST ITEM IN YOUR WARDROBE
Mom's hippie dress from the 1960s.

FAVORITE VIBE TO CHANNEL
Prince, and a Greenwich Village beatnik.

**OBJECT IN YOUR BEDROOM
THAT MAKES YOU FEEL AT REST**
Sally England macramé wall hanging.

PREFERRED METHOD OF CORRESPONDENCE
In person.

MOST WORN-OUT SHOES
Rajasthani slippers
that I wear as party shoes.

Luck

To be lucky, you must show up. Luck can't happen if you're not there to seize it. People who constantly put themselves out there tend to be the lucky ones, because they bump into opportunities, they reach for them, they say yes to them. Luck doesn't happen without effort. Luck is not gambling. Luck is giving yourself to a situation that asks you to take a risk, accept a challenge from someone, rise to the occasion, and take the baton. Luck is embracing chance, and knowing when you are in the right place at the right time.

The year I studied abroad in Rome, I found a bag full of clothes while I was walking to go food shopping near Campo de' Fiori. An odd shoe that was resting on a clean bag near a garbage can caught my eye, like it had been positioned there in a stylish cry for help. Inside the bag I found vintage slips in all the prettiest pale pastels. I took them home to my dorm, hand-washed them, and wore them constantly as I started experimenting with my new European look (prompted, ironically, by the pages of *W* magazine, which I'd buy at the English news kiosk in Trastevere). There was one slip (a filmy lilac A-line, with a deep V-neck) under which I wore a black bikini with a gorgeous hat (splurge). Later that year, I wore my trash-can dress to the Christian Lacroix Haute Couture show in Paris. I'd spent the summer doing an internship, and as a thank-you, they sent me a standing-room invitation. I couldn't afford a taxi, so I took the bus. An usher sat me in the front row without looking at my invitation. At the afterparty, I danced with Mario Testino, who told me he loved my style. I was studying graphic design in school, but I knew I wanted to work in fashion.

Certain classics—treasures found in the moment—feel like fate, destined to be yours. When your heart starts pounding with excitement, you know it's a match.

Dumpster Diving and Barneys

In college, I became adept at combing the newspaper for estate sales. I'd show up an hour early and wait in line. It's true: The early bird gets the worm! When they opened the door I'd run madly through the house, adrenaline rushing, plucking diamonds from the rough. (I now take red stickers that say "SOLD KATE" to tag anything that catches my eye.) I found rare, out-of-print books (*Living with Design* by David Hicks), discontinued styles (vintage Gucci loafers in my size), and things I could not afford retail (an Hermès "H" buckle that I added to a worn-out leather Western belt for a high-low juxtaposition). Thrifting, bidding, and going to garage sales are like fishing—it's about the hunt as much as it's about the catch—you never know what you're going to find. You must be selective about keeping your catch and absolutely love something to bring it into your house. My eye scans the room, sifts a stack of junk, and spots the gleaming nugget that I want. The extraordinary throws itself right

into your hands. When you recognize what you love, it will find you right back. (Remember the lighthouse metaphor?) I especially like estate sales because I get to see inside people's houses and see how they lived. I'm fascinated by what people accumulate, what they love and collect in a life well lived, their unique anthropologic collection of objects.

I started Dumpster diving when I encountered a beautiful church charity shop on the Cape that was open only at odd hours. I'd ride my bike and try my luck. If they were closed, I'd peel back the lid of the Dumpster, peer down, and jump in to pick through the cast-offs. This particular Dumpster was pristine, its contents anything but garbage. I once found a cream-colored crocheted Oscar de la Renta dress in that Dumpster. Years later, I paired that find with Manolo Blahnik heels I'd bought at Barneys and antique jewelry to wear to a fashion show.

Loafers give good ankle:
A perfect pant-to-hem ratio
is achieved with footwear
that shows off some fibulae.

A Vision of Vintage:
Dressing for Nightlife

I spent my twenties in nightclubs and at glamorous parties, first in LA, then in New York. For a solid decade I went out almost every night of the week, and I met everyone I could and had an absolute ball. It was the most style-experimenting period of my life. As a fresh college graduate, I stepped off the plane onto the hot LA pavement and I knew something was different—this was *not* New England. Something big was happening, something I couldn't see but I could feel. Style was brewing inside of me, anything was possible, and it was impossible to contain it. I had to let it out, put it on, and go out and meet others who did the same. This was my big shiny clean slate. As a young adult in a new environment with new peers, I was, in many ways, figuring out who I was, where I'd come from, and who I wanted to be. I was self-aware of my upbringing and for the first time, not taking it for granted. There was a blur of fiction and reality. This era was all about vintage for me. I'd window-shop at Gucci (by Tom Ford) on Rodeo Drive, culling inspiration to copy on my starting salary. Sometimes I'd conjure an outfit inspired by a movie, like Anjelica Huston's white suit and her lacquered nails as she clutched the white telephone, fingering the

coiled cord, in *Prizzi's Honor*; or imagined from photos by Helmut Newton or Guy Bourdin. I figured, *Why can't I dress like that, too?* Finally, I was all dressed up, with somewhere to go: out. I became enticed by my most fearless self.

I created looks based on fantasies, books and magazines, movies and photographic images, a friend, a character, a persona I was channeling, a person I wanted to be—my style was a living sketchbook of dreams and ideas. Trial and error led me to discover who I was and what worked for me. I went out on a limb with everything—clothing, makeup, jewelry, all on a shoestring budget—and I met the most incredibly creative people, many who became clients or were secretly my mentors. I was living a dream.

In LA, I loathed buying work clothes—I hated wearing a bra, and I can't bring myself to dress for a corporate setting. So I mostly wore the same thing during the day: cut-off jean skirt and button-down collared shirt, with Red Sperry canvas sneakers. Every week I combed a checklist of thrift stores in the valley, seeking to reinvent, and never repeat, a look as I cobbled together my outfits to wear out in the evening. There was a recurring party on Monday nights at Les Deux Café, which became a stylish Hollywood hotspot. After a while, we all started to hang out, meet more people, and become a little community of friends. We called ourselves "The Bros" (named after a line from Ludacris's song "Area Codes"). It was a real scene, with a lot of young, green, creative talent on the verge of stardom. We were thick as thieves. The Bros were like a style sounding board— the social experience I didn't have in college.

When I decided to make the move to NYC, I landed backstage and in the front row of fashion—now suddenly a fashion insider with my ear to the ground. I was slowly exposed to the "dial a dress" wardrobe of rotating samples: I'd choose a dress—a look—from a designer runway show, call in the sample, wear it out that night, return it the next day. The original rent the runway. I had an endless supply

of free, borrowed clothing to go crazy with! When the messenger arrived with the garment bag, I'd carefully unzip it and survey its contents—a surprise!—and then improvise with my clothes, mixing in new pieces with trusted favorites.

My style inspiration is a reflection of my interests, my references, my mentors—all of which came pouring out in a giant fashion growth spurt in my early twenties. The more I dressed the way I wanted to, and experimented with new looks, new vibes, and new Kates, the more people noticed me, and the more I connected with people who had similar interests and styles. My style was growing into a reflection of the person I was actually becoming as I followed my dreams. Style is an unspoken conversation that you have with everyone around you. It can have a conspicuous impact or a quiet vibe. An outfit you notice on the subway, a man strolling in the park, a woman peacocking in the street. It speaks loudly on mute, like a secret handshake, an insider understanding, the tip of a hat, a fleeting moment of acknowledgment and excitement that spells out: *This is me*. Express yourself. Let yourself be heard.

DEMET MUFTUOGLU ESELI

Creative director and stylist

ISTANBUL

**FAVORITE ITEM IN YOUR WARDROBE THAT
MAKES YOU FEEL LIKE A CHARACTER IN A MOVIE**
My vintage sunglasses.

QUICK DESCRIPTION OF YOUR OVERALL LOOK
Effortless and timeless classic.

YOUR DAILY UNIFORM
Tailored jacket, cropped pants, high heels.

FAVORITE RESTAURANT AND DISH ON THE MENU
Kale salad at Il Buco.

FAVORITE HOTEL AND ROOM NUMBER
The Bowery Hotel, room 911.

FAVORITE ACCESSORY Gucci necklace.

MOST WORN-OUT SHOES
Yves Saint Laurent suede heeled boots.

**PIECE OF FURNITURE YOU
REALLY LOVE AND USE EVERY DAY**
Eames chair.

WRISTWATCH
Vintage Patek Philippe.

PRODUCT YOU'VE USED SINCE HIGH SCHOOL
NARS bronzing powder.

FAVORITE FONT Caslon.

WRITING IMPLEMENT
Caran d'Ache fountain pen.

CAR The classic-style Range Rover.

MAKES YOU FEEL COZY
My bathrobe. As soon as I get home, I slip into it.

**THINGS YOU USE OCCASIONALLY
AND TREASURE DEEPLY**
My mom's jewelry.

SKILL YOU DREAM OF MASTERING Architecture.

**PIECE OF CLOTHING YOU
CANNOT DRESS WITHOUT** Scarf.

WHAT INSPIRES YOU?
Hard workers and overachievers.

NECESSARY EXTRAVAGANCE
Tropical plants in my office.

PERFECT MEAL A good steak frites.

**FAVORITE OUTFIT WORN BY A
CHARACTER IN A MOVIE**
Olivia Newton John's black leather ensemble in *Grease*.

OLDEST ITEM IN YOUR WARDROBE
Vintage original T-shirts I
collected from the concerts I went to.

GO-TO DRINK
Moscow mule.

SHOE OBSESSION
A classic Manolo pump.

SENTIMENTAL GIFT YOU'VE RECEIVED
A Polaroid book made by my husband.

Customize

The ultimate customization is quality tailoring. You must find a good tailor, someone you trust, because you are collaborating together to create something new. You can breathe new life and extended decades into old clothes and make off-the-rack pieces actually work for your body.

In New York, I found a great inexpensive tailor on the Lower East Side, on Rivington and Essex. I took all my vintage eBay treasures to him: Yves Saint Laurent, Valentino, Guy Laroche, Oleg Cassini. He can take the '80s out of an old Bill Blass suit and make it relevant again. Sometimes it is just a simple hem, a nip at the seam. Other times we completely restructure the original pattern, refit it to my body and my vision. I once took to him a YSL Rive Gauche safari suit: a tunic top that fit me perfectly (no alterations needed) and matching baggy trousers that were gathered in the wrong places and about five inches too short. After a quick discussion of my vision for the bottoms, he remade the pants into cuffed shorts that hit closer to my knee, perfectly proportioned to the tunic and my height. I wore the ensemble to an interview with Linda Fargo at Bergdorf Goodman. A woman in the elevator told me I looked nice. Tailoring can fix, restore, save, salvage, and reinvent.

I took a vintage mink coat to a furrier in Manhattan to replace a tattered lining and had a satin coffee-colored lining made new, complete with my name embroidered in cursive. It looked brand-new. I wear it like a jean jacket.

My husband, Chris, bought the most exquisite Anderson & Sheppard morning suit on a whim at auction: gray bird's-eye cloth, a double-breasted waistcoat, a one-button morning coat, and matching trousers. Bespoke from Savile Row's finest. He purchased it without trying it on, knowing only the suit's measurements and that it was too big (its first owner, a fellow of the same height

as my husband, was a bit more portly), but it was proportioned correctly to tailor. He took it to Dynasty Tailors in Midtown and had it fitted like a glove, and wore it (*something old*) to gallantly receive me on our wedding day, with a flower in the buttonhole of the lapel, as my dad gently handed me off with a kiss.

Embroidery and Monograms

Vanity plates, trunks, towels, linens of all threads, vehicles of transport, jewelry of every metal and stone, stationery…the list of things to put your initials on or inside of is endless. You can tag anything and make it yours. Without getting all preppy and crest-y about monograms, there is something sweet about inscribing or hand-embroidering a personal message inside a garment, especially a gift to your love.

The first Christmas I spent with Chris, I could not decide what to get him. We had fallen in love and I wanted to personalize something for him. I made him a photo album of pictures of just the two of us from our first year together. Then I took his favorite chambray shirt (read: The Gap, dark indigo, dunked in salt water to hasten fading process) and sewed a small heart inside the left breast pocket with red embroidery thread. On the neckband, under the collar, I needled in his nickname. It was invisible to the world, but there for him to enjoy.

Initials can be all that's needed, but consider taking it one step further: both of your initials together with a heart; a quote or phrase; a motto; a favorite object illustrated. And just like that, an everyday object becomes a keepsake, a wink, a kiss from afar.

Save Up

If you wait for it, you will be rewarded with quality, craftsmanship, and charm. Save up for it. Buy only what you truly love. If you're not sure that you love it, wait (a day, a week, a year), and if you can't stop thinking about it, then it's yours. Avoid fast fashion, fast furniture, fast anything. Good comes slowly.

If you only register for one item
for your wedding, make it this.
You can cook every meal in it.
Why is it oval? To fit a chicken whole.

Splurge

I admit it: I have expensive taste. At this point in my life, I know too much about good design, and thrift stores have become overpicked. But I love a deal, a find, a Dumpster dive. But when it's a splurge, I go all out for what I really want. A masterpiece. A singular item. Something from a recurring dream. A deep itch I've put off scratching until just the right moment. Otherwise, I go basic and keep it simple.

Cost Per Wear

Expensive items that last a long time can also become more affordable if you measure things in cost per wear. I love the idea of something that can't wear out or become obsolete, can't be improved, and can't break, or something that is repaired easily (without replacing the whole unit). It makes me happy to buy something for life, and, of course, only time can tell what will ultimately prevail. Wedding dresses not applicable.

Heat and apply to your Barbour waxed coat to prolong its life... twenty, thirty, fifty years strong.

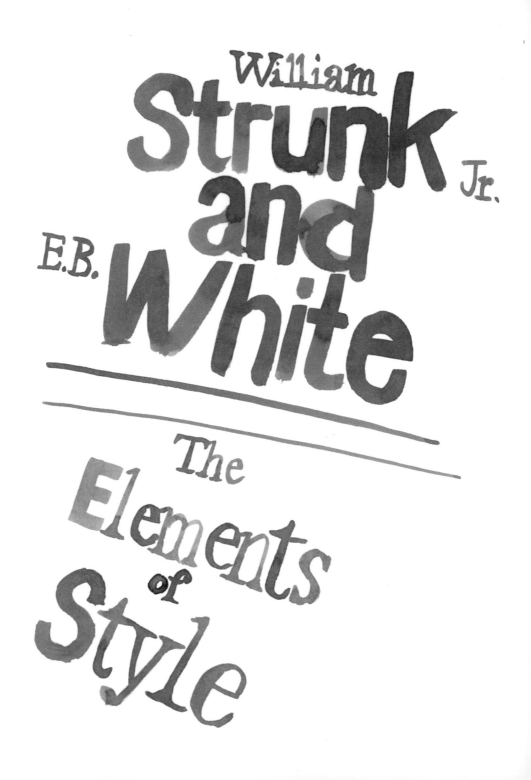

Cheap and Cheerful

Cheap comes in chic packages, too. I think splurges ought to be mixed with affordable pieces. Combining high and low, simple and designer is an easy mantra. Let your eye guide you. Style, like a tide, naturally ebbs and flows at the hand of frugality. Saying no to the newest and brightest, making decisions about what's "worth it" to you, and editing are all good things. Wear your clothes! Wear them up. Wear them down. Wear them out. Wear them in. Don't let them collect dust in your closet. I think it's healthy to second-guess expensive things and be cheap. Ask yourself, *What are they really offering me?*

Do not be tempted by a twenty-dollar word when there is a ten-center handy, ready, able.

— *THE ELEMENTS OF STYLE*

As a stylist I've been able to borrow clothing samples directly from my favorite designers. It's an unfathomable perk. The PR currency helped to drive my business and theirs. Everyone won. But after a while, I noticed that I'd scorched my personal style with a "one and done" approach—wearing something once, and not again, after being photographed in it. My favorite clothes were left hanging in my closet, and I was focusing too much on the new. I had a distinct realization: Ironically, the more I wore my own things, the more the magazines printed my picture (I know, what a crazy industry we work in). I was first captured by the Sartorialist (and his book) while wearing a pink worn-out silk shirt (as a dress), for which I'd paid ten dollars, with a black sash and my favorite Sergio Rossi flat sandals. I was running into the Chris Benz show, and I felt a gentle tap on my shoulder. I was utterly myself and unprepared for the photo—and I love it because it really looks like me.

Impulse Purchases
(*Use This Advice Sparingly*)

Timing is everything. When you finally have money to spend, or need something specific, it can be really hard to find. So if you see something amazing that you love, that fits exactly into your life right now—buy it. I like to sleep on most purchases, but sometimes the moment really is fleeting. When you face an impulse buy, ask yourself: *Would I absolutely wear this now—today or tonight—if I could? If I came back tomorrow and it was gone, would I be disappointed or relieved?* Sometimes there is love at first sight. If you'd wear it out of the store, buy it. Otherwise, find the exit ASAP.

Avoid buying: For the future you.

Avoid buying: For the old you.

Buy: For you today or tonight. Sure, a friend's wedding in a month is okay. If you'd wear it out of the store or out on the town that night, go for it!

Think of impulse purchases as the Farmer's Market of Sales. Like fresh strawberries that are available for only two short weeks per year, snatch up what is in season, what is rare, and what you will use today.

My Dressing Rules (*Please Break Them*)

→ Wear leopard print as a neutral.

→ No brown in town. Instead, try camel.

→ Good coat colors: leopard print, camel hair, khaki, navy, black, perhaps red, white, or army green; yellow slicker.

→ In the summer, white socks with white sneakers only.

→ Black bras, underwear, and stockings hide a multitude of sins for women, except in summer when white is nice and fresh.

→ A deep-V, expansive décolleté is most flattering on women, except when it comes to T-shirts and sweaters. (Go crew neck.)

→ Stick to earrings and bracelets only with a high neckline; wear a necklace with open décolleté or a V neckline.

→ Consider carrying a basket instead of a bag.

→ Carry a pocketbook—long strap, hits at the waist—in the smallest size that will hold your belongings.

→ Women can carry men's wallets—keep your stuff, and logos, to a minimum.

→ Clothing and jewelry sliding scale: The more formal and lavish the dress, the smaller and simpler the jewelry (think: *What would John Singer Sargent paint?*); the simpler the fabric or clothing, the more embellished the jewelry (think: *Madonna's "Dress You Up"*).

→ Diamond earrings should be set to drop just below the lobe—they need to move to catch the light and sparkle (think: Edwardian, Georgian). It's a waste to post them on a stud.

→ Three-stone engagement rings stand for: past, present, and future. They're gorgeous.

- You should be able to see or feel the water on your feet if you're wearing flip-flops.
- Wedges aren't flattering; wear a low sandal with a wide heel if you need to walk on a lawn for a summer wedding. Wear low heels with long gowns.
- Men's pocket squares are really for the ladies: tissue or tears.
- Bikinis should have less fabric—too much fabric looks wrong. Wear a one-piece instead.
- Cinch a belt at your true waist—it accentuates your figure.
- Nothing says elegant romance like a sash over a dress. Tie a ribbon or sash around your waist instead of a belt. Especially light blue or black over a white cotton frock.
- If you wear a patent leather belt, it must match your patent leather shoes.
- The wider the pant, the lower the hem (kisses the ground), the higher the heel. Wear a heel with boot-cut jeans or wide-legged pantsuits, and a ballet flat with cigarette or skinny jeans.
- "Mary Jane" strap shoes shorten the leg.
- Wear exercise clothes to exercise. Then change!
- Wear new shoes five times, then add tips and heel reinforcements. Resole completely only if the shoe really needs it. Invest in the best shoes and cobbler you can afford.

Lipstick in the perfect
shade of red has
otherworldly powers.

Estate Sales and eBay

They don't make 'em like they used to. If you're certain you may not see something again—or it's been long gone for years—get it! Snag it. Stockpile it. Buy in bulk. Store it. eBay and estate sales are the places I let myself impulse-shop because everything I want is rare, and I seldom buy something I later regret. Many of my real treasures are my biggest steals and deals. I like to buy old. Old stuff has built-in character and a story attached to it. So many things I love are ingrained in my imagination but unavailable in the shop. I am an eBay addict who has learned to think like a search engine—and intrepidly comb estate sales—to find simple things that I love, but that have been discontinued or just evaporated altogether from the marketplace. Like fishing or hunting, there is a certain thrill in browsing, searching, and slaying. So I say: If you really love something, hunt it down! It may be rare: your perfect discontinued lipstick shade, your grandmother's tin colander with the pretty perforated pattern and charming little legs, Rainbow flip-flops.

I've been buying discontinued Chanel lipsticks on eBay (gross, I know).

A seasoned cast-iron skillet found at a tag sale is better than new! People work years to build a good patina on their skillets—it's a thing—plus, think of the hundreds of happy pancakes someone else flipped.

Buy It, Try It

There's no better place to try something on than in your own home. Buy it and try it with your own wardrobe, your other favorite stuff. It should fit in like a sibling. Check the store's return policy, try on, buy what you love (don't buy everything—select your absolute favorite), take it home, and hang it in your closet. Play with it. Try it with different shoes and accessories. If you don't wear it immediately (within ten days), return it. The "high is in the buy," and as soon as the transaction has occurred, it's over; you don't need it anymore. That's why "buyer's remorse" is an actual feeling.

STEPHEN KEEFE

Creative Director

NEW YORK CITY

ALWAYS IN YOUR FRIDGE
Heinz ketchup.

**FAVORITE RESTAURANT AND DISH
YOU ORDER ON THE MENU**
Odeon's steak frites.

MOST WORN-OUT SHOES
Common Project white sneakers.

SUNGLASSES Vintage Persol.

WRITING IMPLEMENT
Paper Mate SharpWriter #2 pencil.

FAVORITE FONT
Helvetica.

**FAVORITE NONELECTRICAL
TOOL OR THING**
A hammer.

USEFUL ART SUPPLY
Glue gun.

FAVORITE FABRIC PATTERN
A good toile.

FAVORITE ARCHITECTURAL LANDMARK
The Chrysler Building.

BELOVED MOVIE
The Breakfast Club.

**MOST WOODY ALLEN-MOVIE
KIND OF THING YOU LIKE TO DO**
Worry.

SENTIMENTAL GIFT YOU'VE RECEIVED
The rosary beads that my father gave
to my mother when they were dating.

FAVORITE DISCOVERY
Peanut butter tastes great on everything.

WHO INSPIRES YOU?
My mother.

FAVORITE ALBUM SINCE HIGH SCHOOL
Fleetwood Mac's *Rumours*.

"FORM FOLLOWS FUNCTION" MEANS
Whatever you do should have a purpose.

EVERYTHING GOES BETTER WITH
Family and friends.

**ITEM PACKED IN
YOUR SUITCASE—ALWAYS**
Bathing suit.

**OLDEST ITEM IN
YOUR WARDROBE**
Gucci loafers.

**BOOK YOU KEEP CLOSE
AND REFER TO OFTEN**
The dictionary.

Window-Shopping in the Digital Age

I don't browse, I restock. I don't have the time to go out and see what I "need" in stores—I just know what I need when I need it and I go get it and come right home, or I order it online. No browsing. Just living. Occasionally I'll see something extraordinary that I fall in love with and have to have, but mostly, I have trained my brain to shop like a search engine—type in what I need, find it, buy it, done.

Occasionally, I'll graze online, although online shopping works for me only when I already know what I want and I'm searching for a specific item (for example, repeat purchase, or the store doesn't have my size or color and it's available online). Otherwise, it's impossible to feel the fabrics and cuts. But sometimes I'll browse online. It's like video-game shopping: Search your favorite designers, fill your cart with goodies, check out, and just when you need to enter your credit card info— *poof!*—close your browser window. Get the high without the buy. You'll probably forget what you wanted in the morning.

Sales

Don't buy anything on sale that you wouldn't pay full price for. Period. We've become accustomed to sales, every day, everywhere. Sale! Everything is on sale! Buy it! Now! It's hard to tune it out. A sale must be a little bonus, a little gift of good luck—like a friend picking up the check at lunch. You must not conform to what the store wants you to buy. Just because it's on sale doesn't mean it costs less. Sure, it's priced lower, but buying it could definitely cost you more: emotional baggage, clutter, sorting, storage, tailor costs, maintenance, and time. Buy only what you would pay full price for.

Get Rid of Storage: One In; One Out

Get rid of storage. Simplify your life. If it's out of sight or reach, it's out of wear. You'll never use it. The only things I store are my wedding dress (which I secretly wish I could dye black and wear again, because it is as big as a small car), ski clothes, and winter boots. I can reach everything else in my wardrobe just fine. I wear it all.

Space constraints are a fact of life in New York City and a ruthless editing tool. If I buy something new, it either replaces something older or takes the place of something else. One in; one out. I don't keep both because I can't. There's no room. It's the best way to keep your closet fresh, avoid clutter and thoughtless accumulation, and prevent a bursting wardrobe full of nothing to wear.

I DO BELIEVE...

I do believe in eyeing something, dreaming about it for days, weeks, a year—and buying it when you can afford it. Your dreams can come true.

I do believe in buying what is absolutely YOU—what is useful, looks great, and works with your body, lifestyle, and personality.

I do believe in working hard to save up for what you want, and getting it.

I do believe in making decisions when you shop—you should know how you'll use an item before you buy it.

I do believe in carefully curating every object and activity in your life. Choose what you use.

I do believe in touching every object you own—keep what you love and remove or donate the rest.

I do believe in clothes that last a lifetime, or at least five to ten years, not one season.

I do believe that different body types and lifestyles need different clothes to suit them. Always honor yours.

I do believe in sticking to your look—for you and your body. Rely on what works.

I do believe in trusting your instinct, or a good friend's. You know what you're doing.

I do believe in actively making little investments in the big picture of your wardrobe.

I do believe you should know that what you buy will withstand trends.

I do believe you should know that what you buy is perfect for you—today and in five, ten, or twenty years.

I DON'T BELIEVE...

I don't believe in overspending for a trend that's not you.

I don't believe in buying something you can't afford—you'll regret it and resent it whenever you use it. Find the store's exit quickly.

I don't believe in the adage "Buy one in every color." Choose your favorite one—buy multiples of that color. If you have two similar items, choose one over the other. Focus!

I don't believe in keeping anything you don't love. When you try it on think: *Would I wear it today or tonight? Where does it fit in my house?* If you can't say, then leave it behind.

I don't believe in wishy-washy shopping— it leads to a closet full of clothes with "nothing to wear."

I don't believe in buying your size number. Buy what fits and what's comfortable and *don't* buy anything that doesn't fit your body, your house, your schedule, your life. You will not use it and it's wasteful. Tailor everything that is kind of "off."

"Be yourself. Everyone else is taken."

Own It

The pursuit of cultivating personal style, whether intentional or by default, has captivated me. It has opened my eyes to my muses, my passions, my peeves, and my people. It has taught me to be honest with myself and my family and clients, to be real. It has challenged me to be stronger and flex my courage when I might have been a coward. It has taught me to be myself, jump in, try things, go places, meet people, expand my boundaries, and live. When I found patience hard to come by, I learned to work at my own pace and honor my own process. When I didn't know what I was doing, I followed what I knew first and let the rest come. Go with what you know. Let yourself learn. Mix it up. Fumble freely. Ease is where the nectar lies and where the bees fly.

I know, easier said than done. Exhale deeply and give yourself permission to switch gears. Permission to slow down. Permission to change. Permission to be yourself and go inside for a little bit. Everything is okay. Uncertainty is okay. You have everything you need.

Guts and Grace: Forget What's Cool

My belongings are somewhat of a nondenominational religion, a philosophy that runs deep and close to my heart. I care about the design of objects and how they feel and function. I look for the emotive qualities of architecture, objects, and materials—their spirit—and form deep attachments, akin to a crush. My classics. My Zen obsession. My dad calls it the Designer's Curse. You cannot escape noticing details, and it's an ongoing quest to perfect them.

I have always felt passionate about what I like. I remember my favorite artists growing up in high school (Matisse, Diebenkorn), the ones I vigorously tried to copy, over and over again; the Robert Motherwell painting I stood beneath at the Met, sketching, trying to make it come out of my pencil; the books I asked for at Christmas, the colors I loved as a child, the sounds, the light—they are all the same to me today. I still love them. My taste has strayed but never wavered. I have been exposed to much in my career, introduced to new things, traveled far and wide, encountered artists, designers, creators, and writers who have expanded my encyclopedia of imagery, a vocabulary of "cool," and an appreciation for a diverse compendium of styles—but I find myself returning to what I know and love, deep down, even if it isn't the most popular thing. Despite trends, outside influence, and lots of experimentation, come home to what you love truly. Forget what's cool—make something cool yourself!—at your own pace with your own imagination. This is when you need to improvise with your own instincts: Know when to plan and when to coast, when to ask and when to tell, when to grow and when to take a break. With confidence.

The more you know,
the less you need.

—PATAGONIA

Patagonia founder Yvon Chouinard loves WD-40.
It's inexpensive, it does what it says it's going
to do, and it works. It's good stuff. There is no
better tool to get the job done. Simple. Useful.
Effective. Inexpensive. When my brother worked
at Patagonia's Ventura headquarters, he told me
that WD-40 was cited by the CEO as a benchmark
of branding to live up to. A product whose
effectiveness advertised itself. This stuck with me.

The Mix: When Everything You Love Works Together

Personal style starts with deep obsessions, habits of our good senses we can't kick. When it's meaningful, there is harmony in juxtaposition. Consistency and clarity, across the board, is key. You don't want to look like everyone else, a soldier marching in line. You must fight for beauty, *your* beauty, *your* vision. Beauty can be imperfect and something magnificently "off" to be discovered and interpreted.

 Tension between opposites teases the eye and makes for a glamorous moment, a juxtaposition of surprising elements:

...

Thin and chunky	Ugly and pretty
Loud and quiet	Feminine and masculine
Textured and smooth	Bold and delicate
Giant and tiny	Quiet and deafening
Fast and slow	Blatant and humble
High and low	Modest and confident
Expensive and cheap	New and old
Banal and useful	And so on...

...

LAURA STOLOFF

Fashion editor

NEW YORK CITY

**FAVORITE RESTAURANT AND
DISH YOU ORDER ON THE MENU**
Cafe Mogador's vegetable tagine.

ALWAYS IN YOUR FRIDGE
Apples and lemons.

GO-TO DRINK Water.

SUNGLASSES
Céline cat-eye in tortoise.

FAVORITE HOTEL
Benesse House in Naoshima, Japan,
the oval room (you can get there only by tram).

**THINGS YOU USE OCCASIONALLY
AND TREASURE DEEPLY**
Silver candlesticks (1800s) from my grandmother.

MOST WORN-OUT SHOES
Black Chelsea boots (I've resoled them
three times). They look better with age.
And black high-top Converse.

WRITING IMPLEMENT
Blue Japanese erasable pens.

SNACK
Green juice.

YOUR DAILY UNIFORM
Men's oversized button-
down shirt, jeans, ankle boots,
silk scarves to accessorize.

SENTIMENTAL GIFT YOU'VE RECEIVED
Miró silk scarf, framed, from my grandmother.

FAVORITE PATTERN
Leopard.

JEWELRY YOU NEVER TAKE OFF
Repossi gold ring and small gold hoops.

WRISTWATCH
Hermès tank but longing for a men's watch.

NAIL POLISH COLOR Clear.

**GROOMING PRODUCT YOU'VE
USED SINCE HIGH SCHOOL**
Eyelash curler.

SKILL YOU DREAM OF MASTERING
Metal welding.

FAVORITE PLACE IN THE WORLD
I don't know yet.

**MODE OF
TRANSPORT**
NYC subway.

Finding the One

Anyone who's ever searched for a house or an apartment knows the feeling: After many fails, you finally see one that feels right, and that night, you can't sleep because your imagination is busy arranging your furniture in your new place. True story: I once delivered to a private client an exquisite Oscar de la Renta dress. It fit her *perfectly*: her body type, her personality. But it was pricey, and she asked me: "Do I need this? Where do I wear this?" "To the White House," I replied. I don't know why, but it just came out. I really felt convinced that this dress would find a place in her life. I knew she was an Obama supporter and was active in his campaign. Six months later, she texted me a photo of her shaking hands with the president of the United States—wearing the dress, beaming and beautiful at the White House!

So if you dream of the latest Chanel pumps or Céline bag or Belgian linen for your upholstery—if you come back to it over and over—then go for it. It's no longer an impulse buy, it's the one.

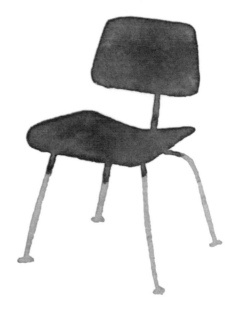

Guess who wore which frame?

Improvise

My love of comedy stems from my love of improvisation and a natural love of laughing and goofing around—playing. Throughout my career, I have taken improv classes at the Groundlings and Upright Citizens Brigade just for fun. Improv is a very creative process—it's about jumping in and thinking on your feet to create, in real time, with your team members. But it also requires a firm structure in which to play, a frame that helps the story move forward and the characters become realistic. And funny.

There is an expression in improv, "truth in comedy," which means that you speak to what you know—your truth. Use specifics (descriptive imagery) and costumes to create characters and plots. If something is really true to life, then it will make people laugh (or cringe). You don't go for the joke. You go for the truth. The truth is funny. A juxtaposition of characters is funny. Hearing a phrase recalled that you once heard someone say in real life is funny. This comedic structure will often pair one "normal" character with one "odd" character—because watching these opposites collide is what creates comedy. Two crazy characters just read as clowns. It's too predictable.

So what does comedy have to do with style? The ability to play and experiment, while being truthful to who you are. Style is honesty. Style is being who you are. I never decide to like something. It's just me or it's not me. Simple. You must go with the flow and think on your feet. You have a frame in which to go for it and let it rip. Everything else falls away.

The most important thing is to have a sense of humor. In life. In fashion. In your career and relationships. Laughing, playing, and doing let you see things from new angles and gain new points of view.

DAVID GRUNING

Marketing and communications executive

NEW YORK CITY

FAVORITE RESTAURANT
Indochine makes me love NYC every time.

SIMPLE ACCESSORY Wallets.

YOUR DAILY ROUTINE
Husband/coffee/work/gym/dogs/breathe/sleep.

GO-TO DRINK
Patron Silver on the rocks with fresh lime
juice (maybe a splash of soda).

CAN'T COOK WITHOUT
Glass baking dish (maybe sad, but true).

FAVORITE CANDY Junior Mints.

FUNNIEST COMEDIAN
The ladies of SNL: Tina, Amy, Kate McKinnon,
Kristen Wiig; John Oliver is my idol.

ICE CREAM FLAVOR
Mint chocolate chip.

FAVORITE ARCHITECTURAL LANDMARK
Empire State Building at night.

WORN-OUT CHILDHOOD TOY Red Radio Flyer wagon.

LUGGAGE
Louis Vuitton Macassar
duffel, L.L.Bean
all-black boat and tote.

BELOVED MOVIE *The Sound of Music.*

MAKES YOU FEEL COZY A Brussels Griffon on my lap.

ON YOUR NIGHTSTAND
Silver piggy bank from childhood that's missing an ear,
mini Maglite, books, blinders from last airline flight, water.

WRITING IMPLEMENT Uni-Ball, ultra-fine point.

FAVORITE FONT
Futura Light, from being brainwashed
at Calvin Klein early in my career.

LESS IS MORE, OR MORE IS MORE?
The best of less makes up for more.

FAVORITE COLOR
All shades of blue, from palest sky to navy.

PREFERRED METHOD OF CORRESPONDENCE
Handwritten notes.

**FAVORITE OUTFIT WORN BY
A CHARACTER IN A MOVIE**
Sean Connery's tux in James Bond's *Dr. No.*

"FORM FOLLOWS FUNCTION" MEANS
Love the very rare perfect balance of both, beauty with a purpose.

GEAR
Babolat tennis
racket.

**PRODUCT YOU'VE USED
SINCE HIGH SCHOOL**
ChapStick Moisturizer SPF 15.

A Classic SOS

When my grandfather died in 1995, Dad called my siblings and me and explained that we should all buy flights to Rochester, New York, for the funeral in two days. At the time, I was sleeping on my sister's couch in New York City and interning at *W* magazine, so I had something to wear to the service. My brother was working at Patagonia headquarters in Ventura, California, which is known for its casual dress code, when he got the call. He was on a business trip, but he didn't have a suit with him.

When Dad picked us up from the airport in Rochester, my brother explained that he needed to buy a suit to wear to the service. "Goddamn it, Graham! You should always keep a blue blazer in a FedEx box under your bed!" my dad shouted. "In case of an emergency, your roommate could send it to you."

We all burst out laughing at his sartorial SOS plan. This was not a plane diving toward the sea, with passengers grasping for life vests below their seats! Who on this planet keeps a navy blue blazer in a FedEx box under their bed for emergencies? We still laugh at this story, and "navy blue blazer" is a classic Schelter inside joke. My dad is the only person I know who considers a navy blue blazer a lifeline. It illustrates the emotional power of a reliable classic. A classic can save the day. We can be hardwired in our preferences.

Let It Happen

Never force invention. *Fashion* gallops toward the future at full speed—yelling "New, new, new! Trends! Trends! Trends!"—yet *style* looks around, looks back, nods to the past, high-fives the present, and considers the future at its own pace. Style pulls from the archives, draws on imagination, and reinforces its vision with unbridled conviction. Don't force it. Everything comes naturally when it's coming from you, and your world, at your pace.

No Shoulds—
Only Cans, Wants, and Will Dos

Timing-wise, I can't deny that my turn inward coincided with meeting my husband, Chris, getting married, and the birth of our daughter, Charlotte. Naturally, my priorities shifted. I have redirected and focused my intention. If I feel that *I should* do something, I know it's coming from my autopilot, from a place of fear or duty. If I feel that *I want to*…or *I will do*, it's coming from passion and interest. Avoiding the shoulds clears a path for so much more.

After a decade of being thrilled by the energy of New York City, I was burned out. My life was on autopilot. I needed change. It had been ten years of store openings, big-budget fashion parties, runway shows, and charity galas— ten years of going out to meet people, hustle to get jobs, impress people enough to remember me after the sparkle of an event faded. I enjoyed the ride, but I eventually tired of it. The life part of my nightlife was struggling.

I didn't want to go out anymore—if only dressing up wasn't so much fun, I might have stopped going out all together. In my gut, I knew I was spreading

myself too thin. I started to catch myself saying: "I *should* go to…" instead of "I'm so excited about going to…" and a lightbulb went off. I'd let the fear of missing out take over. It wasn't that I wanted to be a hermit; I just wanted to be more selective and do things I really wanted to do, that were *me* and not what the world expected of me. FOMO no more.

Today, my heart is my compass. If I catch myself saying, "*I should* wear this," "*I should* do this," or "*I should* meet so and so"—I do not do it. *To thine own self be true*. I do what I can; I see whom I want; I work on what I love. Pare down to what you truly value, and avoid the excess events, obligations, and time-sucks. Instead of giving 20 percent of yourself to acquaintances at fifty different parties, try giving 100 percent of yourself to a friend you've been neglecting, a parent, a sibling, a coworker you see every day but don't know. Give yourself the right to choose what you participate in. Be efficient and effective with your precious time.

JESSE KAMM

Designer

LOS ANGELES AND PANAMA

MOST FUNCTIONAL ITEM YOU OWN, THAT YOU LOVE EVERY TIME YOU USE IT AND NEVER TIRE OF
1985 Mercedes Benz 300D navy blue sedan (biodiesel),
with Channel Islands five-foot-eleven Whip surfboard on the roof.

YOUR DAILY ROUTINE
Wake. Love my family. Work. Love my family. Sleep.

DISHES
My mother is a potter, and all of our mugs and bowls
were handmade by her. I love having her with me at each
meal, even though she is two thousand miles away.

YOUR DAILY UNIFORM
JK sailor pants, button-down, trench.

PRODUCT YOU'VE USED SINCE HIGH SCHOOL
I used Aqua Net in high school—
thankfully those days are behind me.

WRITING IMPLEMENT
Sharpie, ultra-fine, black.

FAVORITE HOTEL
Leo Carrillo State Park, campsite 46.

GO-TO DRINK Aperol spritz.

FAVORITE FONT
Helvetica Neue and Nobel Light.

PREFERRED METHOD OF CORRESPONDENCE
Speaking on a telephone
with a receiver and a cord.

**BOOK YOU KEEP CLOSE
AND REFER TO OFTEN**
*Norwegian Wood: The Thoughtful Architecture
of Wenche Selmer* by Elisabeth Tostrup.

WRISTWATCH
My husband's grandfather's Rolex.

OLDEST ITEM IN YOUR WARDROBE
My crocodile clutch from my
great-grandmother Fern.

NAILPOLISH COLOR
None; buffed not polished.

HAIR PRODUCT Seawater.

FAVORITE DISCOVERY My husband.

WHAT INSPIRES YOU? Mother Earth.

FAVORITE PLACE IN THE WORLD
Anyplace with left-hand waves.

**MAKES YOU
FEEL COZY**
My grandmother's
tartan L.L.Bean robe.

ESSENTIAL TOOL
Gingher scissors.

MOST WORN-OUT SHOES
My canvas and leather Vans high-tops
with the purple palm trees.

You Don't Always Need a Plan

Sometimes you need to be focused, direct, and full of intention; and sometimes you need time for stillness, confusion, and reinvention. Time to let things come to you naturally, without being forced; time to play, to just see what happens, to be who you are (without labels) and step out from the box in which others have placed you or you have placed yourself. A reset. A nonplan plan.

When I have to make a difficult transition I always surround myself with three familiar pillars: friends, cooking, and comedy. They are elemental and there is nothing complicated about them. They are straightforward, like enjoyable busywork. Cook a recipe I love and enjoy the food. Pop in a funny movie or *SNL* rerun and laugh out loud. Get a good friend on the line. It works for me.

When you embrace not having a set direction, you may experience the "dead zone" (dormancy, fear, dread, confusion, self-doubt), but that always comes before the spark of spring. When you give up expectations and rules you sow seeds for creative thought; you give yourself room to find your individuality and your own vocabulary. You are no longer defining yourself in someone else's terms. Yours is the only voice in the room. Take this time seriously and enter wholeheartedly; take the plunge. When you dive into something with freewheeling ease and disregard rules and accepted ways of doing things, you discover your innate ability to experiment and take risks. Give up others' ideas of you. Give up your own idea of you. You must be free to be yourself. Bounce, bounce, bounce…jump in!

Suede elbow
patches: little
life lengtheners.

Step Back

During life's transitions, it takes a ton of courage to decide to *not do* what you've been doing for so long. Getting off the ladder can be harder than putting your head down and charging up the ladder. But without change we stop growing. When something isn't working, the answer isn't always to "try harder." Sometimes you need to change course completely, to be what you see yourself to be, even if that vision is not yet completely clear. If you resist change, you continue swimming upstream, with more of the same problems. Instead, step back and change your point of view.

Change your outfit. Try on something new. Cling to an old favorite sweater to get you through.

Three Things Worth Spending On

A wise old grandparent somewhere once said: *There are three things worth spending your money on, in no particular order:*

3. EDUCATION

1. TRAVEL

2. REAL ESTATE

These expenditures are lifetime experiences that build meaning, character, relationships, and experiences.

Travel Far and Wide

Book a flight, rent a car, hop on your bike, pack your bags—get up and get going!—travel is important to expand your mind, your cultural influences, and your wardrobe. Globetrot, check out a new neighborhood in your city, or take a new route home from work. I tear articles out of magazines and save them in files or go to places my good friends visit. All travel is good for the soul because it opens your eyes and pushes your boundaries. It stays with you for life, and it's the ultimate classroom setting for everything—live in the field.

My favorite hotels and restaurants are overflowing with charm, and guests to match. They are filled with little details that I fall in love with and that make me feel at home. If I can't stay with friends, hotel hospitality is important because it lets me relax into my new environment so I can really experience it: beautiful settings, foreign cultures, food, clothes, ways of life. Everything jumps right out of the environment and right into my heart. I notice everything as if seeing it for the first time.

Rituals, like chicory coffee and fresh biscuits served on a silver tray with Villeroy & Boch's Petite Fleur china at Soniat House, a historical Inn in the French Quarter of New Orleans, are exactly what I seek out and why I stay there instead of at the local Hilton. (I want to replicate their tea service in my own home, or go back again to experience it because the experience is enchanting.)

I fell in love with the groovy sun umbrellas at the Chateau Marmont teardrop swimming pool, along with the exotic lemon tree whose branches dangle above the turquoise water, the little red-and-white safety ring, and the hand-painted cursive "No Diving" sign—I've never seen anything like it before or since—the location touches on nostalgia, a picture I'd seen in a Slim Aarons book, or a postcard from Italy.

On Mount Desert Island, off the coast of Maine, the Jordan Pond House serves up baskets of enormous popovers and tea—nothing fancy, just a sturdy wood table (sans

tablecloth) flanked by Adirondack chairs on an emerald grass carpet, and plates with green trim. I don't know a single place on earth where you could have the same experience: the view overlooking Jordan Pond, the furniture, the popovers.

I have never forgotten these places. I store them in my mind's library, filed under: inspiration. Hotel stationery, handwritten notes, fruit in a basket, flowers by your bedside, robes and slippers, ashtrays you can steal (and pay for later when they bill your AmEx), little soaps, discoveries in nook and crannies, ordering off the printed menu—*could the chef please prepare…?*

REBECCA DE RAVENEL

Designer

LOS ANGELES

ON YOUR NIGHTSTAND Evil eyes.

ALWAYS IN YOUR FRIDGE
Rosé, you never know who is going to stop by.

FAVORITE RESTAURANT AND DISH Sant Ambroeus Cacio e Pepe.

QUICK DESCRIPTION OF YOUR OVERALL LOOK
Feminine and easy.

YOUR DAILY UNIFORM
A long dress, flat sandals, a few rings, and a straw bag are my staples.

GROOMING TOOL YOU'VE USED SINCE CHILDHOOD
Mason Pearson hairbrush, pale blue in color.

SPORT A lot of dancing and a little running.

FAVORITE CANDY Carambar.

BOOK YOU KEEP CLOSE AND REFER TO OFTEN
My dream dictionary. I love waking up after a
dream and trying to make a little sense of it.

FAVORITE FONT Copperplate.

FAVORITE HOLIDAY
Taking off to an undiscovered place.

FAVORITE HOTEL
Singita Faru Faru Lodge in the Serengeti National
Park, Africa; Oberoi Udaivilas in Udaipur, India.

INSIDE YOUR HANDBAG
My mother always told me not to ever let anyone look in my handbag.

WHAT YOU BRING HOME IN YOUR SUITCASE WHEN TRAVELING ABROAD
Printed fabrics.

YOUR PEACEFUL LANDSCAPE
The bay in front of our house in the Bahamas.

SUNGLASSES Thierry Lasry.

WRISTWATCH Vintage Rolex.

MAKES YOU FEEL AT HOME
My bedroom is full of old photos and books and all the little things I have always loved.
It's the combination of things I have collected forever.

PIECE OF FURNITURE YOU REALLY LOVE AND USE EVERY DAY
My vintage shell wicker chairs.

FAVORITE NONELECTRICAL THING My Hermès diary.

SENTIMENTAL GIFT YOU'VE RECEIVED
The box my father had hand-painted for me with all my
favorite things from when I was younger.

"FORM FOLLOWS FUNCTION" MEANS
Nothing…I am not a believer that everything should have a function.
Hence why my house is full of nonessential things and I like it that way.

THINGS YOU USE OCCASIONALLY AND TREASURE DEEPLY
A straw cylindrical bag and a shell necklace. I choose very
carefully when to take them out on the town.

OLDEST ITEM IN YOUR WARDROBE
A black bustier that still has my boarding school
nametag in it. It never fails; it's an oldie but a goodie.

WHAT INSPIRES YOU?
An unprompted act of kindness.

FAVORITE COLOR Blue.

SNACK A coconut.

FAVORITE ARTIST
Brancusi and Klimt—even if I have seen their work a thousand
times before. It's a little bit like seeing an old friend.

COMFORTS YOU LONG FOR
Silence.

NECESSARY EXTRAVAGANCE Fresh flowers everywhere.

Just Ask

I asked a lot of questions as a kid. My mom says it came from her constant reinforcement because she never felt she had courage herself. As the baby of the family, I was showered with a lot of attention and love (and still am today). I was taught that it was safe to be brave. It was okay to speak up. It was necessary.

In school I had another big family: my best friends from preschool and seventh grade, Kathrina Lear and Jaime Dutton, and their siblings and parents. I knew almost all the students and faculty on a first-name basis. I was the kid in class who would ask the teachers what other students were too afraid to ask but everyone wanted to know. I was ballsy (and often too ballsy), and I deservedly got sent to the principal's office for it. But I learned a powerful lesson early on: Asking rewards—you might get what you ask for.

Asking questions and trying options, it seems, are the roots of courage and the foundations of style and design. I spent the summer of my junior year in high school canvassing door-to-door for an environmental group—ringing bells, pounding pavement, and asking complete strangers for money in their own houses. I dressed nicely and was friendly and polite when someone answered the door. I could ask anyone for anything. In college, I worked in the development office for a summer, and the same message was hammered into me: Just ask! I had nothing to lose and everything to gain. Ask and you shall receive. You don't get what you don't ask for. You don't gain what you don't attempt. Baby steps lead to great strides.

Once I got my foot in the door at *Vogue* as a photographer, my job was to get *the shot*, to approach celebrities and strangers alike. I had to be bold in the moment. I asked Beyoncé, Miuccia Prada, Iman, David Bowie, my boss Anna Wintour—"Can I get a shot for *Vogue*?" I quickly got over my stage fright and was no longer starstruck. It was simple: I was either going to get the shot or not. But I'd get nothing if I didn't have the courage to ask.

MEREDITH MELLING

Designer and style consultant

NEW YORK CITY

LUGGAGE
T. Anthony, red, monogrammed "MLM"
(Meredith Louise Melling).

**FAVORITE RESTAURANT AND DISH
YOU ORDER ON THE MENU**
Balthazar, cheeseburger.

PANTRY ITEM
A Seinfeldian collection of cereals.

WRITING IMPLEMENT No. 2 pencil.

SPORT Boxing.

**BOOK YOU KEEP CLOSE AND
REFER TO OFTEN**
Paulo Coelho's *The Alchemist*.

WORN-OUT CHILDHOOD TOY
My stuffed lion, Richard the Lionheart.

FAVORITE SONG SINCE HIGH SCHOOL
"Something in the Way She Moves" by James Taylor.

BELOVED MOVIE
Harold and Maude.

ON YOUR NIGHTSTAND
Baby monitors.

ITEM PACKED IN YOUR SUITCASE—ALWAYS
Jewelry charms with my children's names, one of my father's
sweaters, an XL dark gray classic cashmere V-neck.

SENTIMENTAL GIFT YOU'VE RECEIVED
My husband writes me notes often and
leaves them around the house for me to find.

COMFORTS YOU LONG FOR Naps.

**FAVORITE OUTFIT WORN
BY A CHARACTER IN A MOVIE**
Tie between Keira Knightley's green dress in
Atonement and Gwyneth Paltrow's green
open top and midi skirt in *Great Expectations*.

OLDEST ITEM IN YOUR WARDROBE
Navy L.L.Bean fisherman sweater (was my grandfather's).

NECESSARY EXTRAVAGANCE
Acupuncture facials.

FAVORITE SEASON
Autumn in New England.

EVERYTHING GOES BETTER WITH
Maldon salt.

WHO INSPIRES YOU?
My family.

**FAVORITE PLACE
IN THE WORLD**
A wide-open beach.

YOUR DAILY UNIFORM
Striped T-shirt, jeans, Vans—Go.

SUNGLASSES
Céline.

**FAVORITE ITEM IN YOUR
WARDROBE THAT MAKES YOU FEEL
LIKE A CHARACTER IN A MOVIE**
My vintage furs!

Wear Many Hats

People come in and out of your life for a reason. Sometimes it's luck, or fate; sometimes it's through persistence and networking. While behind the lens as a photographer, I met many people who later went on to hire me for other creative projects. You never know what can happen when you connect with someone. *Vogue* sent me on assignment to Zac Posen's Tribeca atelier to capture the evolution of a couture gown, a story shot over a few days. After this, Zac hired me to shoot and art-direct his spring lookbook. I was wearing his clothes all the time and really loved him and his style. A year later, as a fashion consultant, I introduced him to a European luxury retailer and liaised a capsule collection. Great relationships can blossom into professional collaborations of all shapes and sizes.

In the creative arena, being a "slash" person—creative director/stylist/artist/consultant, model/actress, author/illustrator, writer/director, designer/architect, DJ/producer—is normal. Creatives have many tentacles of talent and wear many hats. Clients often contact me for one type of project (branding) and hire me for another (styling). You never know where a project can lead. My career is built on my work and relationships with my clients. While your work should speak for itself, who you know is important. Introduce yourself; get in front of people. Relationships are the key to life. You can't fake them. They must be sincere, nurtured, and protected, like all good friends.

Parenting Boundaries
That Set You Free

I'd like to talk about the big myth, the work/mom "balance" myth, also known as "juggling." (See also: "having it all.") Calling it a juggling act is a misnomer. By definition, there's no balance in juggling. Juggling is when things are tossed into thin air with a hope that they'll land in a given space, only to be tossed again. It's totally unstable. Juggling is akin to disaster. That's no way to live your life or raise a family. Why would you put your most important relationships in a state of insecurity and flux? For everyone's sake, I aim for a constant state of "decision making." Working mothers and fathers must not juggle. They must make decisions and follow through on intentions they believe in and schedules they can stick to. Whether you decide to

work full-time, part-time, or be with your child all day, if you make an intentional decision—a plan—it will serve you well.

Clearly defined boundaries are a healthy life move for everyone in the family. Boundaries won't cage you in. They will set you free. Decide what you want and make a commitment that you can keep. You will be working more when you need to work and parenting when you are spending time together with your family. Whatever it is you decide, whatever percentage of the time pie you eat, you must own your decision, commit to your decision, and create consistency to foster your decision (which will help you focus and thrive).

Homeyness

What makes a place homey? You do. You make a home your home by how much you love and use everything you surround yourself with: books that are read often, plants that are watered and well cared for, clocks that tick, music playing in the background, warm kitchens and fireplaces you can hover around; toast with jam and teapots in cozies; good condiments in your fridge (capers, Hellman's, olives, a wedge of Parmigiano-Reggiano, pickles); fresh flowers, and fruit in a basket. Setting the table with your grandmother's dishes, and cooking basmati rice in the copper pot that you brought back from Paris in your suitcase (you just made the weight limit). Naps. Baths in a claw-foot tub with a brass faucet, bathing suits hanging from the outdoor shower, laundry drying on the line. Brick pathways with moss, gates that latch, hefty wooden doors that are plumb and swiftly shut with a satisfying, safe *kerthump*. The ring of the cord-connected landline and asking "May I please speak with…" when someone picks up (the receiver)…in other words: lots of signs of the people who live there.

Houses serve a function of design; they shelter us. They nurture us. A space to be in your pajamas and totally relaxed. A place to invite friends into and display your interests and style on the walls, floors, and in your furniture choices. A house that combines warmth and personality is a three-dimensional map of the people who live there, pockets of personality, inviting and charmed to the max because of those who create their lives inside the walls. Home is a place to be yourself. The mixture and juxtaposition of things is more important than the stuff itself. If you love everything in your house, it all goes together.

I love houses where homework is written around the kitchen table, an in-progress art project peeks out from the sidelines, a neighbor has stopped by for tea, the piano is practiced, food is on the stove, and baskets overflow with tennis rackets, soccer balls, and ice skates. A hat collection hanging by the door gives you a real sense for who lives inside and what they love to do.

I seek things that make me feel at home—at ease, comfortable in my own skin. I try to find a balance between schlumpy and high-gloss. I love a wooden farm table covered in my grandmother's antique dishes. Home has a sense of familiarity, people and things that exude warmth, friendliness, and cheer—it's where I want to be.

LUIGI TADINI

Creative director and brand consultant

NEW YORK CITY

BREAKFAST Espresso and two Marlboro Lights.

GO-TO DRINK Old-fashioned.

QUICK DESCRIPTION OF YOUR OVERALL LOOK
Classic, relaxed but appreciative of things
that are well made; floppy hair (I ascribe
to the French school of hair care).

CAN'T COOK WITHOUT
A wine opener.

DISHES
White ceramics by Hawkins New York.

FAVORITE RESTAURANT AND DISH
Rigatoni Pitti at Bar Pitti.

POTS AND PANS Copper pots.

FAVORITE INGREDIENT Love.

FASHION IDOLS
A mix between Alain Delon
and James Dean.

MOST WORN-OUT SHOES
Vintage Nikes.

BELOVED MOVIE *Out of Africa.*

WRITING IMPLEMENT
Prime Timber 2.0 mechanical pencil.

PREFERRED METHOD OF CORRESPONDENCE
Postcards when I am on the road.

SPORT Sunbathing.

**WHAT YOU BRING HOME IN YOUR
SUITCASE WHEN TRAVELING ABROAD**
Candles, books and exhibit catalogs, perfumes,
and a few extra pounds.

ITEM PACKED IN YOUR SUITCASE—ALWAYS
A navy suit—you never know.

WHEN YOU NEED TO ESCAPE
The beaches of Cape Cod (I feel complete
when I'm in the water).

MAKES YOU FEEL COZY
Fresh pressed linen sheets.

**FAVORITE
NONELECTRICAL
TOOL OR THING**
Gardening tools.

SENTIMENTAL GIFT YOU'VE RECEIVED
Stamp collection owned by my great-grandfather.

COMFORTS YOU LONG FOR
My family in Brazil. I miss them every day.

"FORM FOLLOWS FUNCTION" MEANS
The beauty in the everyday,
the beauty in nature.

EVERYTHING GOES BETTER WITH
Music.

**JEWELRY YOU
NEVER TAKE OFF**
Rolex and family crest ring.

Heart on Your Sleeve

I like relatable stuff, things we can all use. "Less is more" is based on the premise that form follows function, but, to me, that can also imply coldness, darkness, emptiness, gray stainless steel—a plainness that has so much purpose it no longer has a heart, something inhuman. I love functional items that work and invite you to use them. That's why coffee in a round cup and saucer is universally comforting (especially when the barista has affectionately hand-poured milky froth in a heart pattern). It's functional and it says, Hello, my friend.

At Apple, Steve Jobs and Jonathan Ive obsessed over designing high-tech devices in the shape of a rectangle with rounded corners, and the resulting patented design is functional *and* feels nice in your hand. You want to pick up the friendly device and play with it. It has a heartbeat. It's personal. People have their favorite mug that they cuddle up with each morning to ease them into their day, or their favorite old sweater with elbow patches that gently hugs them when they need one. Too many hard angles feel pretentious and foreign, too many smooshy things feel unsophisticated and unreliable— timeless classics exist where the two juxtapose and kiss.

DAVID FOXLEY

Writer and editor

NEW YORK CITY

FAVORITE FONT Vintage typewriter.

ALWAYS IN YOUR FRIDGE A1.

QUICK DESCRIPTION OF YOUR OVERALL LOOK
Aspiring northern Italian automotive
mogul with a midcentury haircut.

**WHAT YOU WEAR WHEN GETTING
DRESSED IN UNDER THREE MINUTES**
St. Paul's School sweatpants and a
T-shirt from the 2006 US Open.

WRITING IMPLEMENT
Silver Caran d'Ache fountain pen
(with Iroshizuku ink in fuyu-syogun hue).

**WHAT YOU BRING HOME IN YOUR
SUITCASE WHEN TRAVELING ABROAD**
Matchbooks and ashtrays (even
though I no longer smoke).

**FAVORITE NONELECTRICAL
TOOL OR THING**
My English bulldog, Jack.

DISHES Vintage Wedgewood
for everyday; (Does Dodi Thayer
count, if we never eat on it?)

FAVORITE ACCESSORY
1985 Ghurka
leather-and-canvas briefcase.

SHOE OBSESSION Sperrys.

FRAGRANCE
Hermès Eau
d'Orange Verte.

ITEM PACKED IN YOUR SUITCASE—ALWAYS
Orlebar Brown swimsuits in fun solid
colors like baby blue and bright red.

**THINGS YOU USE OCCASIONALLY
AND TREASURE DEEPLY**
My mother's silver.

LESS IS MORE, OR MORE IS MORE?
Quality over quantity, always—
better to have one cashmere sweater
than ten ill-fitting polyblends.

SKILL YOU DREAM OF MASTERING
Woodworking.

USEFUL PROFESSIONAL TOOL
Blackwing pencil—super sharp at all times.

NECESSARY EXTRAVAGANCE
Taxis.

**THE MOST WOODY ALLEN-MOVIE KIND
OF THING YOU OWN OR LIKE TO DO**
Wander around a museum on a
weekend with someone I love, ignoring
the paintings, deep in conversation.

FAVORITE PLACE IN THE WORLD Home.

**PREFERRED MODE
OF TRANSPORT**
Jeep Grand Wagoneer.

Start It (and Keep Moving Forward)

Go start something. Don't worry, wait, or wonder too much. You'll get in your own way. Instead, go forward. Move on. Keep momentum. I spent many years of my career—especially when I was young and unsure—seeking answers from mentors; waiting for yes or no decisions; even wondering if guys I dated would call me when they said they would—all of which place the power and authority in the other person. Waiting for approval absorbs so much precious energy that can be spent on doing something productive!

As I grew older and earned more experience, I learned to do things on my own terms and timeline, to please myself, and to move on my own schedule, and my life started to click into place. If you feel yourself waiting for answers, do something to fill the space. Have you ever noticed when you're waiting a long time for your food at a restaurant, it finally arrives once you excuse yourself to go to the washroom? A watched pot never boils. Distraction is not the point. Precious momentum is. Don't depend on outside sources to keep an idea alive. Practice the ability to fill the unknown; be afraid of something and do it anyway; make the hard decisions yourself. Sometimes you already know; you just have to let yourself hear your own voice.

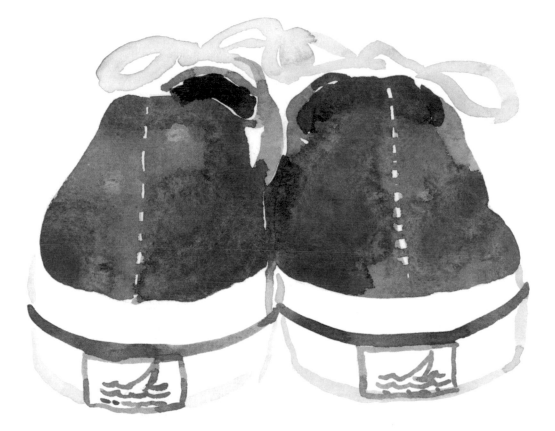

Patience vs. Perseverance

It took me a long time to learn the difference between patience and perseverance. Moving forward is the key to both. Patience is more about removing yourself from the ticking stopwatch. Getting rid of the finish line. Patience is *knowing*. Patience is durable conviction and allowing the time for things to unfold. Being patient is proactive and empowering.

Perseverance is navigating the difference between patience and just plain waiting. It's actively deciding when to wait and when to work, knowing when to watch and when to force a hand. You must persevere in the face of challenge.

Neither are passive. Patience takes willpower. Perseverance takes self-awareness. Neither is hoping someone else will solve the problem or do it for you. Persevere with patience and do it yourself. No one is going to save you.

Own It

When it comes to creative matters, I believe that you must serve yourself before serving the tastes of others. I always think of the airplane oxygen mask analogy: Put yours on first so you can then help others. This approach will lead you to your true passions.

 Leaving the path and paving your own way is hard. It requires knowledge, guts, and good instincts. Muster creativity, a willingness to fail, a desire to succeed, and confidence in your own ideas. Owning your story means inventing your own rules, rather than blindly conforming to codes of conduct made by someone else. (But at least know the rules before you break them.) When you allow yourself the freedom to sort out your own interests and values and pursue your own passions, your life comes into sharper focus. Everything becomes easier. Have confidence. Own what you like. Own who you are, and, most importantly, own what you love to do and bear your own imprint on the world. You have to own it: your life, your choices, and your own mistakes as well.

<center>
Find your unique mix.

Have less.

Do more.

Be more.

Be yourself.

Today.
</center>

COLOPHON

This book was printed in 2017 and typeset in four classic typefaces:
Linotype Didot (designed by Adrian Frutiger in 1991,
based on Fermin Didot's design from the 1800s in France),
Fournier (designed in the 1920s by Monotype, based
on Pierre Simon Fournier's design in about 1742),
Neutraface (designed by Christian Schwartz in 2002, based
on Richard Neutra's principles of architecture and design), and
Proxima Nova (designed by Mark Simonson in 2005).

The original illustrations in this book were hand-painted
on Fabriano paper (founded 1264 in Italy) with
Winsor & Newton watercolors (founded 1832 in
England; patented paint tube and cap 1904).

ACKNOWLEDGMENTS

This book is the culmination of all the best eyes and minds helping guide my effort to create something lasting and meaningful. It would not be possible without My Dream Team!

I would like to thank my friend David Kuhn, who called me on the eve of my first solo exhibit in New York, with the idea for me to write and illustrate this book, offering to be my agent; and Kate Mack, who delightfully guided me through the entire process effortlessly and fastidiously, with care, each day and draft. I am lucky.

I am grateful to my brilliant editor Brittany McInerney (a fellow salty Massachusetts-er) who understood my vision from the beginning and wanted to help me tell and show my story. You provided perfect structure for all my ideas—a natural skeleton—on which I could hang my work, until the whole thing made sense. In the words of E. B. White, you made *every word tell*. I could not have created this book without you!

My friend Andy Spade, thank you for lending your eyes to this book. Since I first landed in New York City, I have admired your ideas, thought process, and way of life. You make things that you believe in, modernly engaging in history and tradition—stylish by default.

Thank you to the whole team at Grand Central including Karen Murgolo, Tom Whatley, Yasmin Mathew, Amanda Pritzker, Shelby Howick, and copy editor Deborah Wiseman.

Sarah Gifford, what a dream to collaborate with a book designer who speaks the same graphic design language and who brought my work to life on the page, giving it a home.

Thank you, my friends:

David Netto, for your guts, grace, and good instincts;

Rebecca de Ravenel for your Bahamian bohemian style;

Jane Herman for plane-Jane denim—straight up simple style;

Jesse Kamm for your California cool, Kamm pants, and rotary dial telephones;

David Foxley for your pencils and sweaters with elbow patches;

Ethan Leidinger (aka Heathbar) for your grown-up Boarding School style;

David Gruning (aka China) for your companionship and sense of humor, mint chocolate chip and ChapStick;

Stephen Keefe for glue guns and Gucci loafers;

Meredith Melling for stripes and vintage coats;

Rita Konig for loving breakfast in bed on fine china and chintz;

Anne Caruso for polka dots and chocolate chips;

Demet Muftuoglu for sunglasses and shoes, love and warmth always;

Julia Chaplin, for Gypset enclaves;

Laura Stoloft, for needing less;

Luigi Tadini (aka Squeege), for friendship and so much good advice;

Frances Tulk-Hart for fearless barefoot fashion, and film;

I would like to thank *Fresh Air with Terry Gross*, and *WTF with Marc Maron* for hundreds of hours of listening material while I paint in my studio. I do my best work when I'm listening to you guys.

I am grateful to Petra Baptiste who lovingly cared for my daughter Charlotte while I wrote and painted this book. With your trust and help, I am able to do the work that I am passionate about.

Thank you to Patrick Cline for taking my portrait and Patrick Emanuel, my digital guru. Beverly Hall, your Schelter family portrait is my most beloved artifact.

This book is a love letter to:

My dearest family and friends,

My parents and siblings,

My husband (xo-ie) and daughter,

My collaborators and confidantes,

My mentors and educators,

My heros.

. . . and to all the wonderful people I have worked with in New York City, Los Angeles, and beyond—you know who you are!